IMAGES
of America

HOOVER DAM

IMAGES
of *America*

HOOVER DAM

Renée Corona Kolvet

ARCADIA
PUBLISHING

Published by Arcadia Publishing
Charleston, South Carolina

Printed in the United States of America

Library of Congress Control Number: 2012955600

For all general information, please contact Arcadia Publishing:
Telephone 843-853-2070
Fax 843-853-0044
E-mail sales@arcadiapublishing.com
For customer service and orders:
Toll-Free 1-888-313-2665

Visit us on the Internet at www.arcadiapublishing.com

For the dreamers, designers, and hopefuls

CONTENTS

ACKNOWLEDGMENTS

The images in this volume came predominantly from the United States Bureau of Reclamation (USBR); the University of Nevada-Las Vegas, Library Special Collections (UNLV); and the National Park Service, Lake Mead National Recreation Area (LMNRA). Other images came from the University of Nevada-Reno Library Special Collections (UNR); Boulder City Museum and Historical Association (BCMHA); Los Angeles Public Library Photograph Collection (LAPL); Library of Congress (LOC); National Archives and Records Administration (NARA); Imperial Irrigation District (IID); Lost City Museum; Nevada State Museum, Las Vegas; United States Geological Survey (USGS); the Nevada Historical Society; and individual collections.

Many people helped make this book interesting by sharing knowledge or images, or helping with graphics, including Mark Cook, Patricia Hicks, Regina Magno, Alexander Stephens, Brit Storey, and Emme Woodward of the USBR; Kelli Luchs at UNLV; Erin Eichenberg and Bryan Moore of LMNRA; Lisa Ray of the Colorado River Commission of Nevada; Gary McBride of Lincoln County Power District No. 1; Dennis McBride of the Nevada State Museum, Las Vegas; Lynda Trimm of IID; Donnelyn Curtis and Kimberly Roberts of UNR; Laura Hutton of BCMHA; Dena Sedar of Lost City Museum; Keith McDonald of Railroad Pass Casino; Amy Benson of USGS; Seth Shanahan of Southern Nevada Water Authority; Norman DeLorme; Bob Estes; Virginia "Beezy" Tobiasson; and Jeffrey Wedding.

I would also like to thank my husband, Alan H. Simmons, for his support; Martin Einert, PE, for technical advice and editing; Stacia Bannerman of Arcadia Publishing for her guidance; and Suzanne Rowe for urging me to write this book.

INTRODUCTION

Hoover Dam's grandeur draws millions of visitors each year. When completed in 1936, the dam was the largest federal project of its kind. Although larger dams have since been built, the 776.4-foot-high concrete giant continues to awe the masses. The dam epitomizes human dominance over nature—the mighty Colorado River. Born 12 million years ago, the Rio Colorado is a relatively young river. It originates in the Rocky Mountains and follows gravity for 1,400 miles through seven states before flowing into the Gulf of California. On its downhill journey, it cuts through 6,000 feet of ancient rock formations and plateau lands, carving out the magnificent Grand Canyon along its way. The river has been described as "too thick to drink, too thin to plow" for the massive amount of silt it carries. Although it is not the largest river in the Western Hemisphere, it can be treacherous. In his book *Colossus: The Turbulent, Thrilling Saga of the Building of Hoover Dam*, Michael Hiltzik describes the river's "schizophrenic" moods, which can change from a peaceful meander to a violent torrent in an instant. Legally, the Colorado River is one of the most regulated and litigated rivers in the world.

Hoover Dam has represented many things to different people since its inception. Nevadan James Hulse recalls his excitement as a child of having this world-class structure built at the edge of his home state. The dam was often compared to the Great Pyramids of Egypt and was thought of as the Eighth Wonder of the World. In *Big Dams of the New Deal Era*, authors David Billington and Donald Jackson associate Hoover Dam with Pres. Franklin Delano Roosevelt's social and economic programs. Indeed, the dam was the largest federal construction project in the nation and stood as a symbol of American pride throughout the Great Depression. It provided a glimmer of hope to thousands of unemployed Americans. The prospect of steady work attracted job-seekers from every state in the union. Sadly, their numbers often exceeded the available jobs. To agriculturalists in Imperial and Coachella Valleys, a high dam and an All-American Canal would curb rampant flooding and transform the desert into one of America's garden spots. Probably the biggest benefactor was the fast-growing metropolitan Los Angeles area. Amidst a multi-decade growth spurt, California officials and land developers fought for Hoover Dam and the Colorado River Aqueduct and won. The small railroad town of Las Vegas also benefitted from the influx of tourists and the federally funded defense industries and military facilities that followed.

The story of Hoover Dam actually begins decades before a single rock was ever turned. The decision to build an unprecedented high dam materialized after half a century of political maneuvering, river explorations, and scientific surveys. Fascination with the West became part of the American psyche by the mid-1800s. The concept of Manifest Destiny, or America's God-given right to lands west of the 100th Meridian, led to several government-sponsored explorations into the western frontier. The United States was well prepared to extend its political influence to the Pacific Ocean following the Mexican War of 1848 and new land acquisitions in California, Arizona, and New Mexico. The excitement of westward migration appealed to a somber nation in the aftermath of the Civil War. The lure of inexpensive land and gold and silver strikes overshadowed the limited water in the West.

Congress sponsored several expeditions to map and study the western frontier, including the Lower Colorado region. The Ives Expedition passed through Black Canyon and the Las Vegas Wash during a trip from Yuma, Arizona, in the late 1850s, and in 1871, Lt. George M. Wheeler surveyed the southern Nevada area. In 1869, Maj. John Wesley Powell launched his first expedition to the Rocky Mountain region. His journey ended at the confluence of the Virgin and Colorado Rivers. Powell warned that there was far more land than water in the unconquered territory. By then, however, a monopolization of land and water by land barons and speculators was underway. Irrigating the West appealed to the masses and western lawmakers, who needed agriculture to boost economies following the collapse of mining and the 1890s depression. Neither limited water nor common sense could stop the westward movement.

Powell outlined a plan to control large waterways and reservoirs and to construct engineered systems to transport water to interior locations. The massive irrigation systems proposed were beyond the means of the states and local entities, so the responsibility fell to the federal government. The federal Reclamation Service (later the Bureau of Reclamation, or USBR) was formed in 1902 to help settle the West. The prospect of Hoover Dam—once only a dream—began to materialize.

After years of drilling and geological studies, the federal government selected a single dam site in Black Canyon between Arizona and Nevada. The dam's designers took a gamble. They knew that an unprecedented structure would be necessary to tame the wild river. A dam failure could destroy the downstream towns of Needles, Parker, and Blythe, and devastate the Imperial Valley. Although some said it could not be done, the project moved forward soon after passage of the Boulder Canyon Act of 1928. Pres. Herbert Hoover appropriated construction funds for the dam on July 3, 1930, and the project moved forward without delay. Contract specifications for the concrete arch–gravity dam were prepared in USBR's Denver office. Six Companies Inc. of San Francisco was awarded the contract to build the dam and appurtenant works. At the time, the $48,890,996 bid was the largest contract ever awarded by the federal government. The dam was completed in slightly less than five years—nearly two years ahead of schedule. Lake Mead also filled quickly, and storage reached 24 million acre-feet in 1938.

Following the completion of the dam, many workers and their families left the area. Boulder City's population shrank to 2,500 by 1938. Those who remained were employed by the USBR, the National Park Service, power companies, and businesses. There was a dam and a powerhouse to run and parks, campgrounds, and boating facilities to operate.

As visitors poured in from around the globe, the town of Las Vegas grew and expanded. The city was proud of its role as the gateway to Hoover Dam. Meanwhile, military installations and defense industries fostered the spread of Las Vegas to the south along the Boulder Highway and to the northeast toward the Las Vegas Air Corps Gunnery School (Nellis Air Force Base). McCarran Field opened in 1948 with 12 commercial flights a day. New resorts on the Las Vegas Strip, beginning with the El Rancho Vegas in 1941, expanded Las Vegas into the desert to the west. These early Strip resorts put Las Vegas on track to becoming the entertainment capital of the world. Tourists in Las Vegas often visited the dam and lake, and Congress established the nation's first national recreation area at Lake Mead in 1964. That year also witnessed the dam's 10-millionth visitor.

As the southern part of Nevada grew, so did Southern California and locations downstream from Hoover Dam. As the dam project wound down, the construction of the All-American Canal (AAC) System, including the Imperial Diversion Dam and Desilting Works, the 80-mile long AAC, and the Coachella Canal, assumed center stage. The AAC system, built between 1934 and 1940, would supply reliable and relatively silt-free irrigation water to the Imperial Irrigation District in Imperial Valley as well as the Valley and Reservation Districts of the Yuma Project (California and Arizona) and the Gila Project in southwestern Arizona. Due to labor shortages during World War II, the Coachella Canal was not completed until 1948.

Roughly contemporary with Hoover Dam and the AAC was the 242-mile-long Colorado River Aqueduct, completed in 1941. Aqueduct water came from Lake Havasu, behind Parker Dam, and was pumped through mountain tunnels and desert valleys to the Metropolitan Water District

of Southern California (MWD). Although not authorized by the Boulder Canyon Act, Hoover Dam's storage capacities and flood control made the Colorado River Aqueduct feasible. MWD vowed to purchase hydroelectric power from the federal government to offset construction costs. As a boost to the economy, thousands of Americans found work on the AAC and the aqueduct during the Great Depression.

Benefitting from Hoover Dam, farms in the Imperial Valley and the Yuma Project produced much of the nation's winter crops. Following the Reclamation Act of 1902, families were encouraged to settle in irrigation projects established in arid or semiarid regions of the West. Individual families were given up to 160 acres of previously unusable land to farm. In exchange, the settlers would repay the federal government for building the water transportation systems. By the 1930s, farms in California were large corporate concerns, and the small farmer could no longer compete or afford his own farm. Sadly, the small family-run farms promoted by the USBR less than 30 years earlier began to disappear. Expanding agriculture and the need for low-wage labor led to new problems for local and state governments in California and Arizona. When word of farm jobs hit the newspapers, unemployed workers and Dust Bowl refugees headed for California farming communities only to find thousands of migrants lined up for jobs before them. Between 1935 and 1939, an estimated 300,000 people, primarily from Oklahoma, Texas, Arkansas, and Missouri, headed west on Route 66. The migrants experienced some of the hardships confronted at Hoover Dam five years earlier, but only worse. Photographer Dorothea Lange and her husband, economist Paul Schuster Taylor, documented the tragedies suffered in Imperial Valley and other farming communities in An American Exodus. Lange and Schuster referred to this movement as "Last West."

To heal old wounds between California and Arizona, the federally financed Central Arizona Project (CAP) was authorized in the early 1960s. The project delivered Colorado River water to agricultural, municipal, and Indian lands in the Phoenix and Tucson areas. The project put an end to decades of water conflicts between California and Arizona that predated the 1922 Colorado River Compact. In 1963, the Supreme Court limited California's withdrawal to its allocated 4.4 million acre-feet of water per year. The Golden State would no longer be able to rely on river diversions in excess of that amount, as it had assumed in the past.

By the 1980s, Las Vegas witnessed exponential growth unforeseen when the Colorado River Compact was signed in 1922. At the time, Nevada's meager 300,000 acre-feet yearly water apportionment seemed generous for a state with a population of less than 70,000. Today, Nevada is following Southern California's footsteps in its quest for new water sources. Southern Nevada survived the latest economic slowdown, and tourism is returning to pre-recession levels. Up to 40 million tourists visit Las Vegas each year. Lake Mead National Recreation Area draws another 8 to 10 million boaters, anglers, campers, and swimmers annually, and another one million people tour the dam and powerhouse. Now more than 75 years old, the dam is aging gracefully. A covered parking garage and new visitor center were added in the 1990s to accommodate the flow of visitors, and traffic over the dam was redirected over the Mike O'Callaghan–Pat Tillman Memorial Bridge, which opened in 2010. Several larger dams have been built since Hoover Dam, but few rival its greatness. It will always be remembered for its magnificent setting and imposing presence, and for the role it played in the development of the southwestern United States.

One

PRECURSORS TO
A HIGH DAM

Beginning in the late 1800s, pioneers toiled to make the Imperial Valley into a garden spot. The private California Development Company (CDC) provided the first irrigation water to the valley. The CDC relied on the force of gravity and built a canal from the Colorado River below Yuma to the ancient course of the Alamo River, below the Mexican border. By 1903, a total of 100,000 acres were under cultivation. Floods, however, were constant threats to prosperity, and having a canal south of the border created uncertainties. A huge blow occurred during the wet years of 1905 to 1907, when the raging Colorado River changed course, poured into Imperial Valley, and created the Salton Sea. The CDC collapsed soon thereafter, and the Imperial Irrigation District (IID) was formed in 1911.

IID was represented by California attorney Philip David Swing, who led the fight for a high-storage dam and an "All-American Canal." Swing continued to gather support for the Boulder Canyon Project after being elected to Congress. The Los Angeles area was simultaneously engaged in a campaign for a dam on the Colorado River. Fearing that Southern California's growth would surpass its water supply, William Mulholland of the Los Angeles Department of Water and Power (LADWP) knew that the Colorado River was the answer, but it would have to be controlled. Los Angeles boosters and IID embarked on a five-year public relations campaign to win Congressional approval for the Boulder Canyon Act. But first, the river needed to be apportioned. Under the Doctrine of Appropriation, water rights accrued to entities that first diverted it for beneficial use. Without an agreement, California would end up with a disproportionately large share. Herbert Hoover, then the secretary of commerce, created the Upper and Lower Basins for management purposes. The states of Colorado, Wyoming, Utah, and New Mexico formed the Upper Basin; and California, Nevada, and Arizona formed the Lower Basin (parts of New Mexico and Utah were in both). With Arizona abstaining, six states signed the Colorado River Compact on November 24, 1922. After several attempts, the Swing-Johnson Bill moved forward, and the Boulder Canyon Act was passed in 1928.

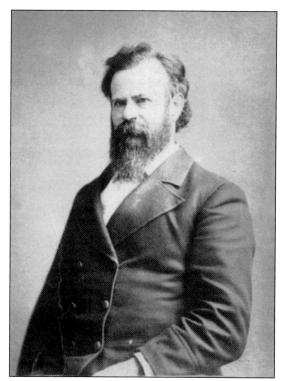

Maj. John Wesley Powell (1834–1902) was a Civil War hero, an explorer, a scientist, an ethnologist, and an environmentalist. He also served as the second director of the United States Geological Survey (USGS) and was head of the Bureau of American Ethnology. Best known for his exploratory expeditions of the Colorado River and the Grand Canyon, Powell understood the limits of the Colorado River Basin. (Courtesy of NPS, Grand Canyon National Park.)

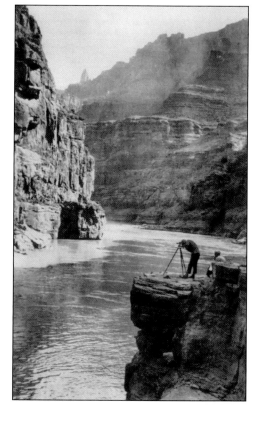

USGS engineer Claude Birdseye and his crew prepare maps and collect data on stream flow and geology during the 1923 Colorado River expedition, the last of its kind. The USGS continued to explore multiple dam sites even after the Bureau of Reclamation had selected a site for a high dam on the Lower Colorado River. River runners still navigate using Birdseye's precision maps. (Courtesy of USGS.)

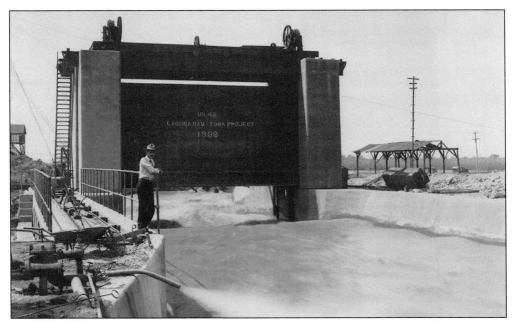

Pres. Theodore Roosevelt signed the Reclamation Act into law on June 17, 1902. The act created the US Reclamation Service (known as the Bureau of Reclamation after 1923) to administer the Reclamation Fund, which financed irrigation works. Shown is the sluiceway gate at Laguna Dam in the Yuma Project, which was built in 1908 to divert Colorado River water to the Yuma and Gila Valleys in Arizona. (Courtesy of USBR.)

The Colorado River floods of 1905 and 1906 devastated the Imperial and Yuma Valleys. The flooded channel is seen here downstream from the Imperial Canal on April 30, 1905. A relentless wave of floods collapsed the old Alamo River channel and caused the river to change course. Walls of water rushed toward Imperial Valley, causing millions of dollars of damage to farms, towns, and the Southern Pacific Railroad (SPRR). (Courtesy of USBR.)

A series of relentless floods caused the Colorado River to breach its banks and flow toward the sub-sea-level Salton Trough. The newly created Salton Sea then stretched for more than 100 miles north to south, from Indio to below the Mexican border, and 50 miles east to west, from the Santa Rosa to the Chocolate Mountains. This photograph was taken near SPRR's Salton Station, 205 feet below sea level. (Courtesy of USBR.)

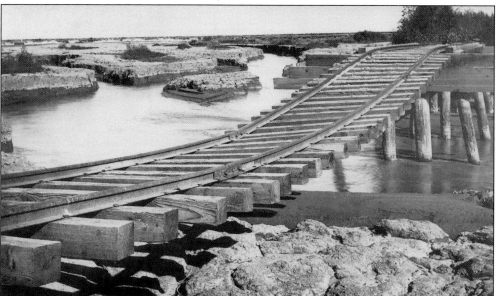

The SPRR suffered millions of dollars of damage during the Colorado River floods. Torrential currents mangled these railroad tracks on September 1, 1906. (Courtesy of USBR.)

SPRR officials inspect flood damage to their tracks. Pres. Theodore Roosevelt pressured the railroad into repairing the break and restoring the river's course. Soon, every available train in the Southwest went to work dumping loads of timber and rock across the collapsed intake. On February 10, 1907, the Colorado River resumed its normal course. The campaign for a storage dam and an "All-American Canal" intensified after this calamity. (Courtesy of IID.)

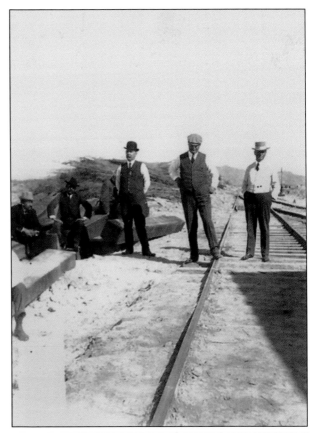

Imperial Valley farmers feared that irrigation water that flowed through Mexico might be disrupted by the Mexican Revolution, which was raging below the border. Lee Little's wheat fields, seen below in 1913, flourished despite the conflicts. The formation of the Imperial Irrigation District (IID) gave farmers hope and a voice in their futures. (Courtesy of IID.)

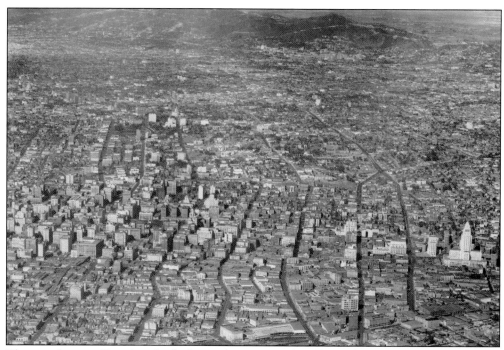

This aerial view of Los Angeles looks northwest toward Hollywood around 1930. The new city hall is in the lower right. The metropolitan area went through an explosive growth spurt between 1920 and 1930, with the population jumping from 936,455 to 2,208,492. Today, Los Angeles is the second-largest metropolitan area in the nation. (Courtesy of LAPL.)

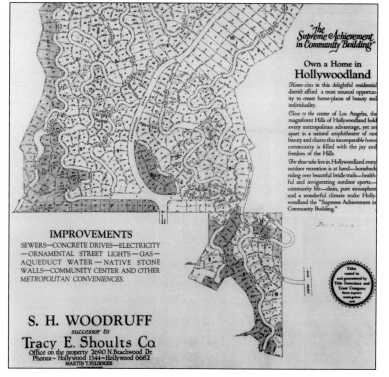

"Aqueduct water" was a selling point for Hollywoodland Tract No. 6450. When Los Angeles exhausted its wells and streams, it had no choice but to look elsewhere for water. Aqueducts were built to transport water from the Owens Valley in central California, and later from the Lower Colorado River. (Courtesy of LAPL.)

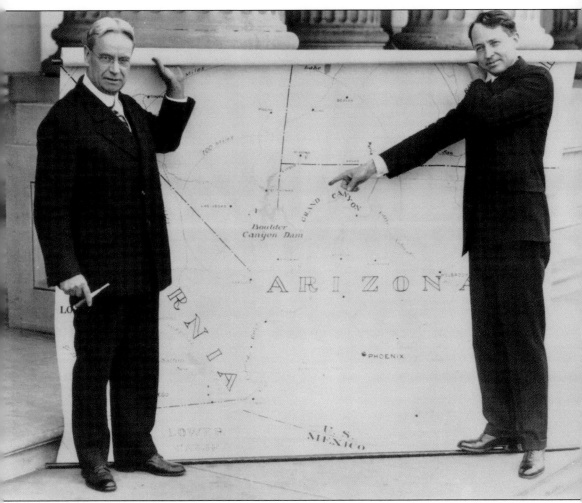

Sen. Hiram Johnson (left) and congressman Philip D. Swing were staunch promoters of Hoover Dam and the Boulder Canyon Project. The duo coauthored the Swing-Johnson Bill, which led to the Boulder Canyon Act and the construction of Hoover Dam, All-American Canal, and its associated works. (Courtesy of LAPL.)

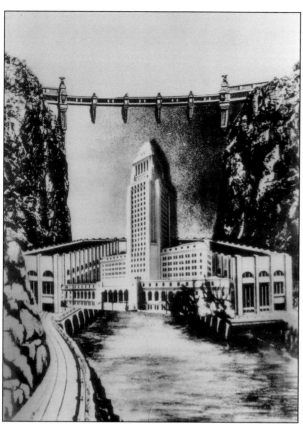

This promotional drawing of the Los Angeles City Hall, built in 1926, and Hoover Dam conveys their critical relationship as well as the dam's incredible proportions. Los Angeles' continued prosperity depended on water from the Colorado River. In the middle of the Great Depression, Southern California voters approved a bond issue to finance the Colorado River Aqueduct. (Courtesy of LAPL.)

The three individuals most credited with securing Colorado River water for Southern California were, from left to right, Frank E. Weymouth of the USBR, William Mulholland of the LADWP, and W.P. Whitsett of the MWD. Here, the trio attends the Colorado River Aqueduct's ground breaking in 1931. (Courtesy of LAPL.)

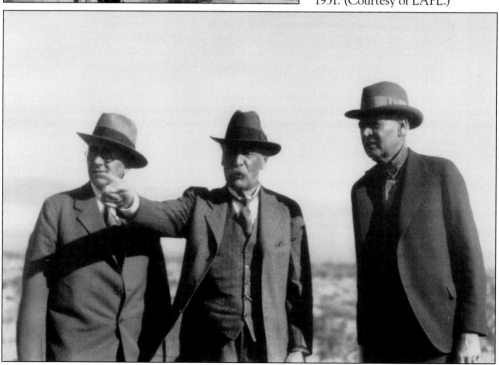

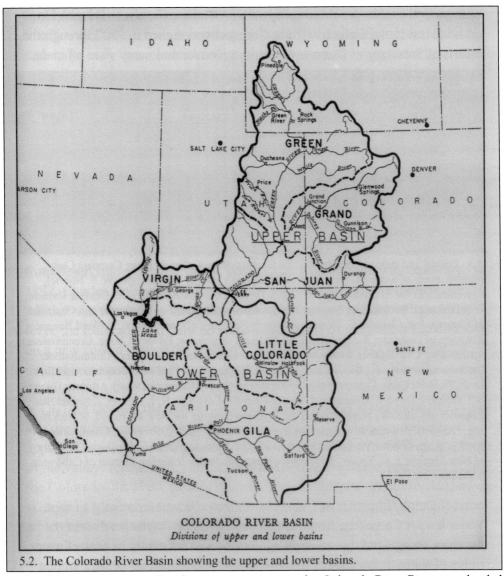

COLORADO RIVER BASIN
Divisions of upper and lower basins

5.2. The Colorado River Basin showing the upper and lower basins.

To legally appropriate river flow between seven states, the Colorado River Basin was divided into the Upper and Lower Basins during the negotiation of the Colorado River Compact. Based on an optimistic annual flow of 17.5 million acre-feet (maf), each basin was allocated 7.5 maf. The remaining 2.5 maf was divided between Mexico (1.5 maf) and the Lower Basin (1 maf). (Courtesy of LOC.)

The Boulder Canyon Act that authorized Hoover Dam and its associated works took 20 years to approve. Pres. Calvin Coolidge signed the act into law in December 1928, less than a year before the stock market crash of 1929. The National Archives and Records Administration (NARA) recently added the Boulder Canyon Act to its list of the 100 most important documents in American history. (Courtesy of NARA.)

Two

A Quiet Desert Land

Hoover Dam is in the eastern Mohave Desert, one of the hottest and driest regions in the United States. The population of southern Nevada before Hoover Dam was quite low. The region was occupied by small groups of Southern Paiute and the Mojave Indians long before white settlers arrived. Despite the harsh climate, native peoples survived for centuries because of their intimate knowledge of the environment and its natural resources.

The Colorado River attracted the first Anglo settler to the area, and the followers of the Church of Jesus Christ of Latter-day Saints were the earliest pioneers. Mormon leader Brigham Young decided to establish an outpost on the Colorado River to aid travel to Salt Lake City. The first riverboat reached Callville in 1866; however, access problems led to abandonment of the settlement within a few years.

In 1865, the Mormon town of St. Thomas was founded at the confluence of the Muddy and Virgin Rivers, 40 miles northeast of the dam site. The pioneers grew cotton to alleviate shortages created by disruptions in supply routes during the Civil War. When the transcontinental railroad usurped the town's strategic location on the river, most residents left the area, but settlers returned in the 1880s, and St. Thomas rebounded. Residents worked hard to create a solid community. The town was shaded by tree-lined streets, and a bustling commercial area was established with mining and freight forming the economic core. Settlers planted fruit orchards and fields of barley and wheat. The Union Pacific Railroad (UPRR) spur line was extended to St. Thomas in 1912, and the Arrowhead Trail (Highway 91) ran through the town.

Later, in 1905, the hamlet of Las Vegas was formed to service the San Pedro, Los Angeles & Salt Lake Railroad. Within a year, the Las Vegas-Tonopah Railroad connected with Las Vegas, and the town became an important transportation hub. By 1930, town businesses and 5,165 residents were located in a cluster of blocks surrounding Fremont Street. Hoover Dam would soon change everything.

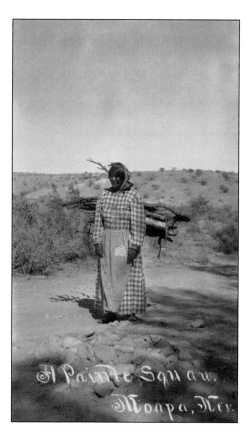

This unidentified Southern Paiute woman from the Moapa area continued to live in the way of her ancestors. By 1913, when this photograph was taken, many elders were still living in brush wickiups. (Courtesy of Nevada State Museum, Las Vegas.)

In 1913, an unidentified Southern Paiute couple poses with Edna Hess (right), wife of Harry Hess, who was a schoolteacher at Moapa River Day School. The Indian woman is crafting a traditional utilitarian basket. (Courtesy of Nevada State Museum, Las Vegas.)

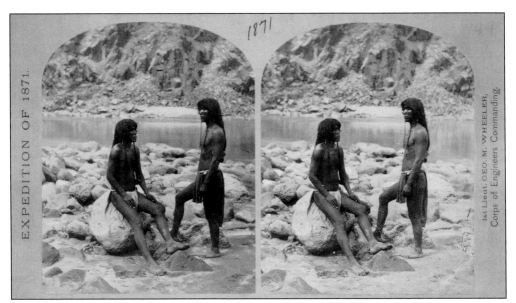

Photographer Timothy O'Sullivan found these two unidentified Mojave Indian men along the Colorado River during the Wheeler Expedition in 1871. (Courtesy of LOC.)

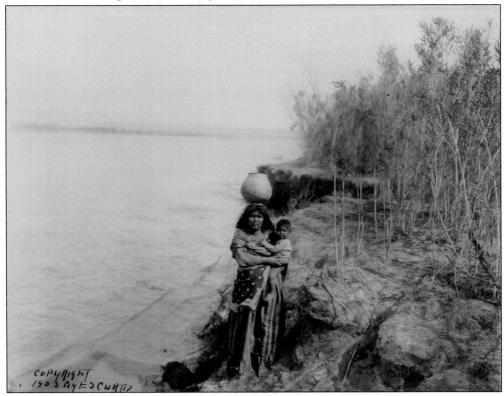

Photographer Edward Curtis captured this unidentified young Mojave mother with a pot of water on her head and a child in her arms in 1903. The Colorado River below Hoover Dam was in the center of traditional Mojave territory and was the lifeblood of several Colorado River Yuman-speaking groups. (Courtesy of LOC.)

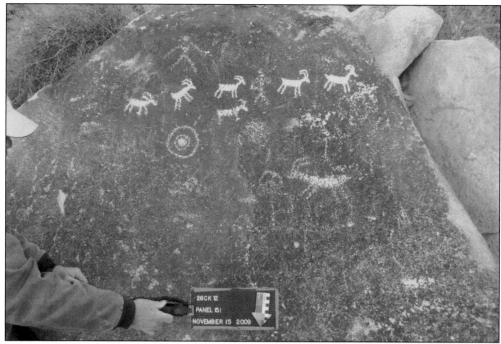

Southern Nevada mountain ranges have been a habitat for Desert Bighorn Sheep for hundreds if not thousands of years. Ancient petroglyphs of herds pecked into rock outcroppings near the Colorado River attest to their importance to native peoples. (Courtesy of LMNRA.)

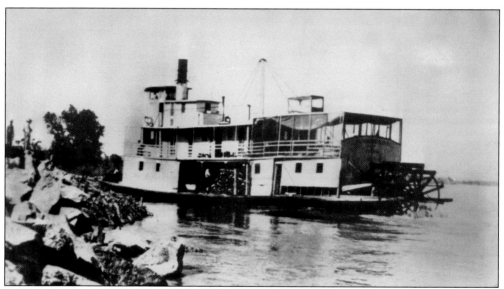

Paddle-wheel steamboats carried cargo, ore, and passengers between forts, mines, railroads, and towns. *Searchlight* was known as the last boat on the river. Built in Needles, California, in 1902, it initially serviced the mining camp for which it was named. The coming of the railroad and the construction of Laguna Dam in 1909 marked the end of steamboat travel. (Courtesy of LMNRA.)

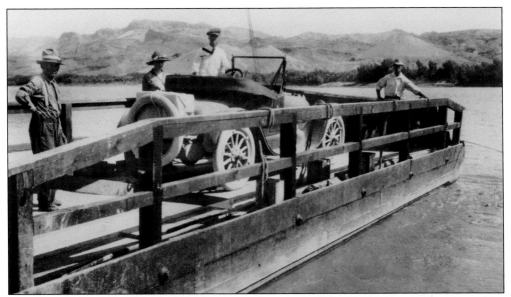

Riverman Murl Emery (third from left) ran a ferry at Cottonwood in the pre–Hoover Dam days. Emery took dignitaries, including Pres. Herbert Hoover, on inspection tours of the dam site, and later, he ferried dam workers to their jobs. He ran a boat shop and store in Williamsville and sold supplies, often on credit, to residents who came in without a dime to their names. (Courtesy of UNLV.)

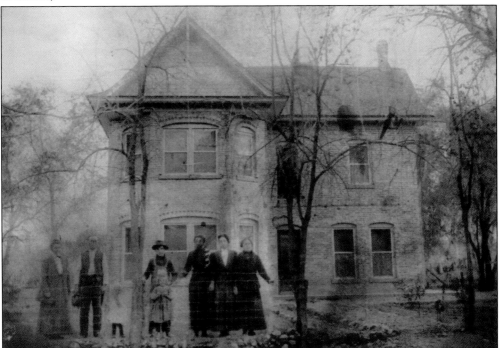

The 14-room Gentry Hotel in St. Thomas was built for travelers and visitors. Nevada's elected officials, including Sen. Key Pittman and Rep. James Scrugham, occasionally stayed at the hotel while on local business. The hotel was dismantled in 1935 by resident Rock Whitmore, who used the building materials for his new home in nearby Kaolin. (Courtesy of Lost City Museum.)

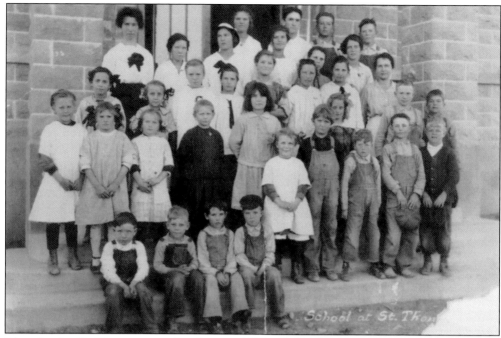

The school at St. Thomas opened its doors in 1915 and closed in 1932 following the government buyout. This smiling group of students poses with the teacher, a Mrs. Arnold, and the staff on the school steps around 1915. (Courtesy of Lost City Museum.)

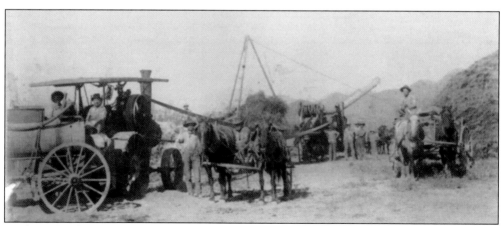

A wheat-threshing machine was shipped to St. Thomas though the Isthmus of Panama and up the Colorado River by riverboat. This photograph shows a ripe field of wheat being threshed in 1923. Miles of ditches carried water from the Muddy River to orchards and other warm-weather crops. (Courtesy of Virginia "Beezy" Tobiasson.)

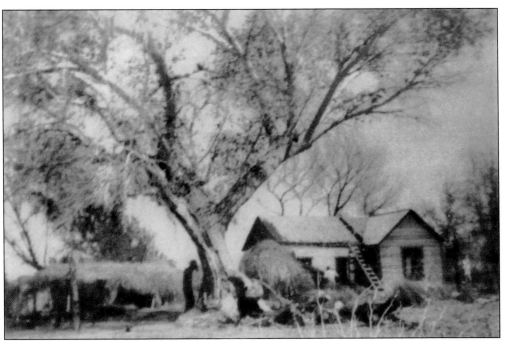

St. Thomas residents John and Nellie Perkins built this home during the good times. The tree-lined streets turned the desert green and made the hot summers more bearable. (Courtesy of Virginia "Beezy" Tobiasson.)

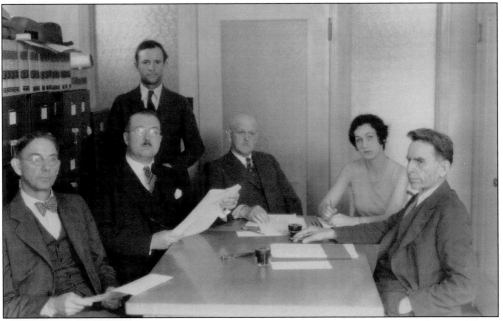

Lake Mead would inundate St. Thomas within a few years of the completion of Hoover Dam. USBR employees met with Appraisal Board members Cecil Creel of UNR's Agricultural Extension Office (second from left); Harry Crain of Cheyenne, Wyoming, (center); and Levi Syphus, of St. Thomas (right) to discuss buyouts. Syphus tried in vain to raise appraised values for his neighbors. (Courtesy of UNLV.)

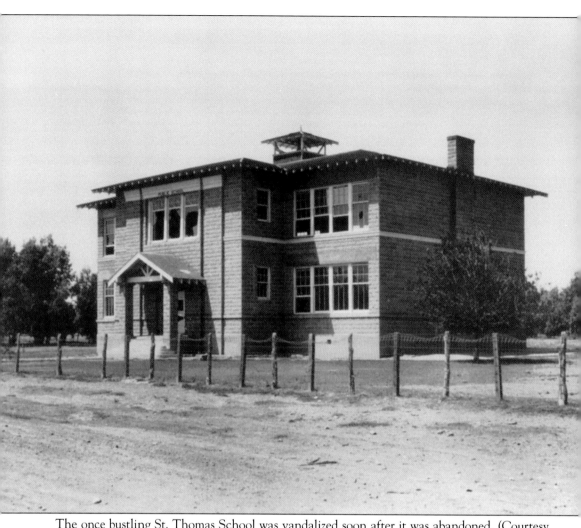

The once bustling St. Thomas School was vandalized soon after it was abandoned. (Courtesy of Lost City Museum.)

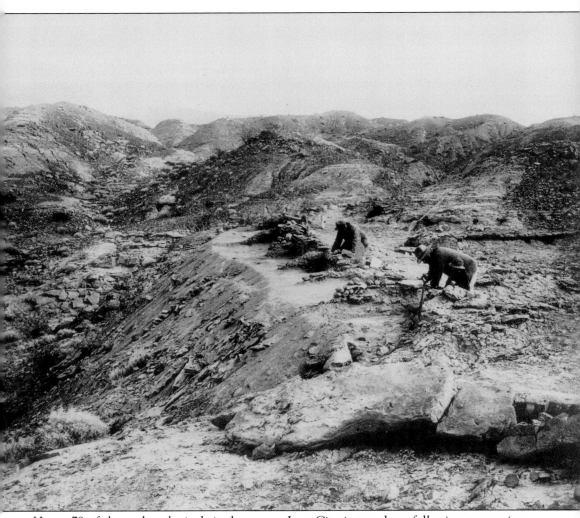

House 79 of the archaeological site known as Lost City is seen here following excavation. Archaeologist and director Dr. Mark R. Harrington photographed amateur archaeologists J. McDonald, Orville Perkins, and Glen Lee at Lost City in 1934 and 1935. A pile of potsherds marks the location of a burial. (Courtesy of LMNRA.)

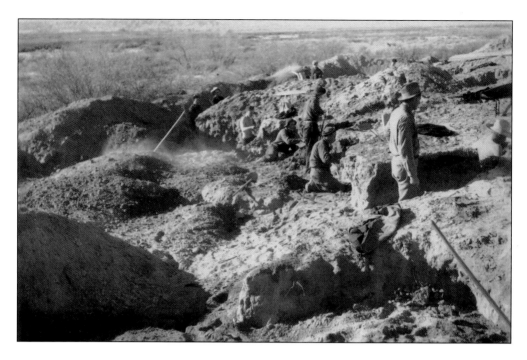

Civilian Conservation Corps (CCC) enrollees from Camp Overton provided the bulk of labor for the emergency archaeological work at Lost City in the mid-1930s (above and below). With Dr. Mark Harrington's guidance, local residents Faye Perkins and Willis Evans taught enrollees excavation methods. (Both, courtesy of LMNRA.)

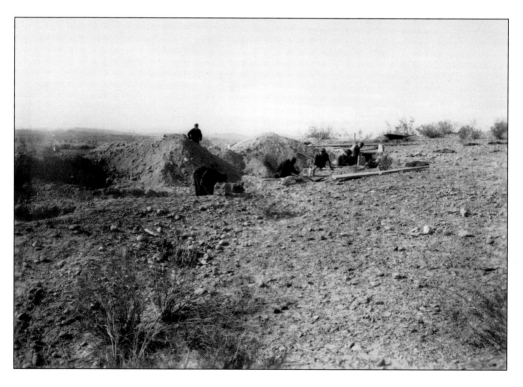

Three

BUILD IT AND THEY WILL COME

In the August 1931 *Reclamation Era*, Mrs. D.L. Carmody writes, "The prospect of work lured them to the dam site and most of them are forced by failure to remain . . . They stay on and on, prisoners of hope."

Newcomers were shocked by the lack of facilities when they arrived in 1931. Many ended up living in tents and shanties furnished with cots and dynamite-box furniture. Poor working conditions, inadequate housing, and record-breaking temperatures resulted in dozens of deaths that year. While limited housing was available in Las Vegas, most people camped outside of town. Some preferred to stay near the dam project and slept wherever there was a level patch of ground. The settlements of McKeeversville, in Hemenway Pass, and Williamsville, or "Ragtown," on the Colorado River, sprang up overnight. Other squatters settled in Railroad Pass and had to adjust to loud music, intoxication, occasional fights, and open prostitution behind the casino.

One Chippewa-Cree Indian family that camped in Ragtown like many others was that of William DeLorme, who was a miner from Montana. DeLorme had no trouble finding work in the diversion tunnels. Sadly, the Bureau of Indian Affairs removed DeLorme's three youngest children for not attending school and took them to the Stewart Indian Boarding School in Carson City. Schools were later established at McKeeversville, Railroad Pass, and Boulder City.

Building Boulder City was a top priority. But homes were only available to permanent employees of USBR, Six Companies, and local businesses—the unemployed were not welcome. USBR commissioner Elwood Mead decided to build a grandiose master-planned community on a hill west of the dam, which would be designed by world-renowned architects. Tree-lined streets radiated from the USBR administration buildings at the head of town. Boulder City residents enjoyed modern appliances, running water, and electricity from the dam. By the middle of 1932, a total of 900 buildings and homes were completed and 100 more were underway. Permanent and temporary housing was built in anticipation of a smaller town after the dam was built. The population peaked between 7,000 and 8,000. For a time, Boulder City was one of Nevada's largest towns.

Many job-seekers stayed in Las Vegas auto camps with shade and sanitation. The majority of squatters, however, camped along the Salt Lake Highway (above, now Las Vegas Boulevard North) or on the road between Las Vegas and Searchlight (below, now Boulder Highway). Despite an increase in crime and the strain on city resources, Las Vegas welcomed the influx of people and the prosperity that came with the dam. (Both, courtesy of UNLV.)

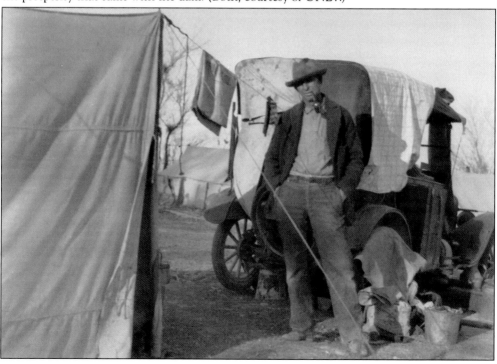

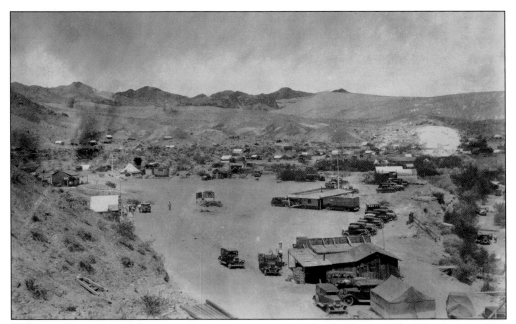

Williamsville, commonly known as Ragtown, was on the Colorado River, north of the dam site. The camp was founded after McKeeversville became crowded. Hundreds of men, women, and children made the best of a bad situation while awaiting housing in Boulder City. Concerns over disease and poor sanitation eventually led to the forced evacuation of Ragtown. (Courtesy of LMNRA.)

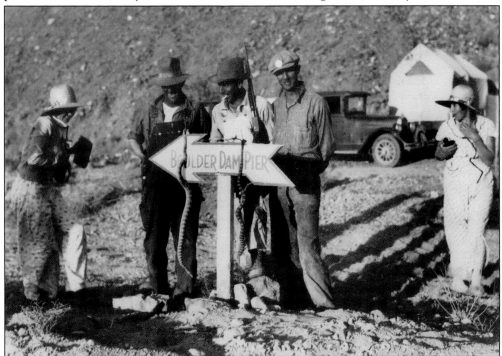

Ragtown residents were plagued by rattlesnakes, scorpions, and biting ants, which invaded tents, sleeping bags, and clothing. These men show off their kill, while two women maintain their distance from the dead rattlesnakes. (Courtesy of UNLV.)

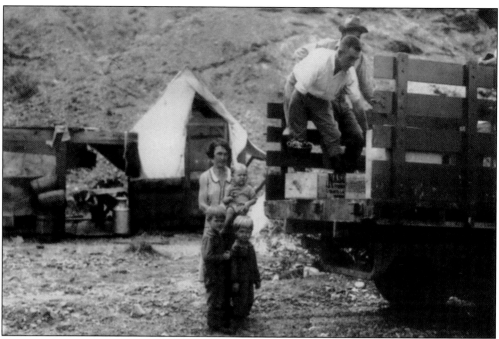

Here, food is distributed at Ragtown during a work strike. Residents normally purchased groceries from Murl Emery's store, and fresh produce was delivered from Las Vegas. Without refrigeration, staple foods usually came from a can. (Courtesy of UNLV.)

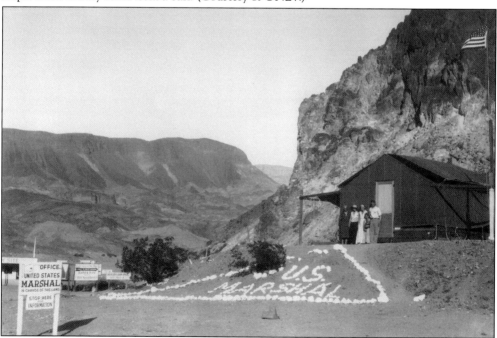

US marshal Claude Williams, for whom Williamsville was named, resided at the camp. On May 7, 1931, the *Las Vegas Review Journal* covered Williams's first major raid. Responsible for maintaining an alcohol-free work environment, Williams ran a veteran moonshiner from Virginia out of town after realizing that an automobile shop in Railroad Pass was really a distillery. (Courtesy of UNLV.)

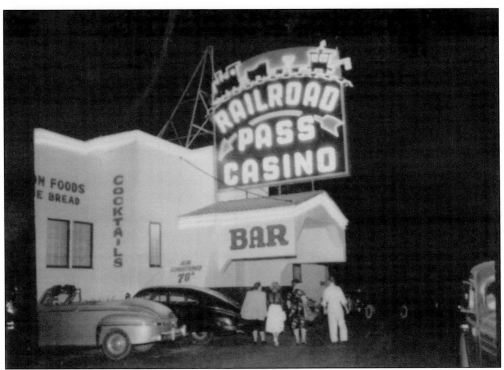

Seen here in 1948, the Railroad Pass Casino remains the oldest continuously operating casino in Nevada. During Prohibition, illegal drinks were served to the customers who knew the password to get inside. Its original barrel-shaped roof was hidden by a new facade. Locals came here to gamble and dance to the music of local bands. Prostitute shacks also dotted the hillside behind the casino. (Courtesy of BCMHA.)

In the absence of a financial institution, the Railroad Pass Casino served as a bank for Union Pacific workers and residents of the squatters' camps. Dam workers' hard-earned pay was kept in a large cast-iron safe inside a locked vault. (Author's photograph.)

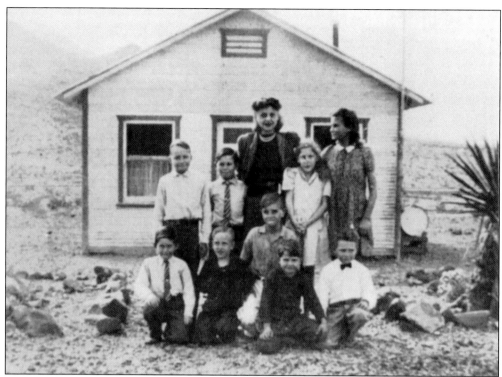

Railroad Pass School was built by the residents of Railroad Pass with support from the Railroad Pass Casino. The one-room schoolhouse was attended by children of all ages and was later enlarged to accommodate a growing enrollment. It remained open until around 1943, when a new school was built in Henderson. (Courtesy of BCMHA.)

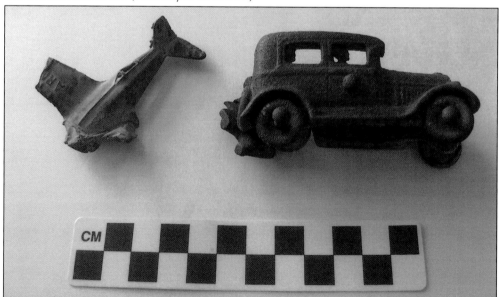

Untold numbers of children were raised in squatters' camps. This pot-metal Tootsie brand toy airplane and rusted motorcar were left at a squatters' camp. These small treasures were probably brought to southern Nevada with the family's meager possessions. (Courtesy of Jeff Wedding.)

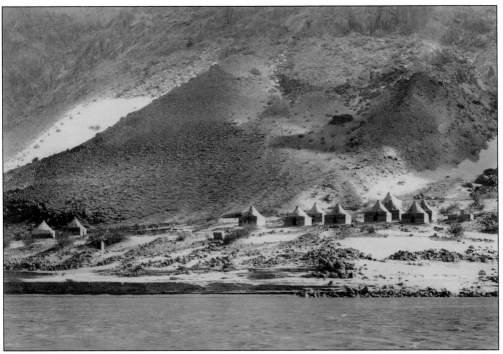

Engineers lived in government tents on the river before federal dormitories were built. This photograph was taken on April 10, 1931. (Courtesy of UNLV.)

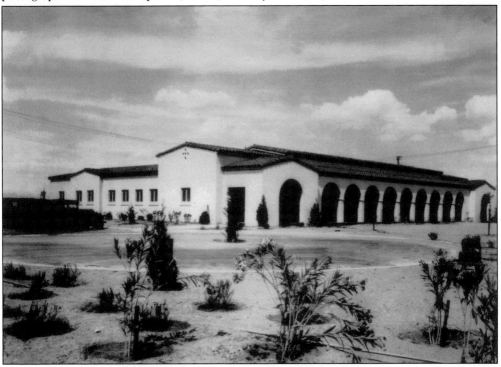

This Spanish-style dormitory and annex was built for unmarried USBR engineers. Today, this building is used by the USBR administration. (Courtesy of USBR.)

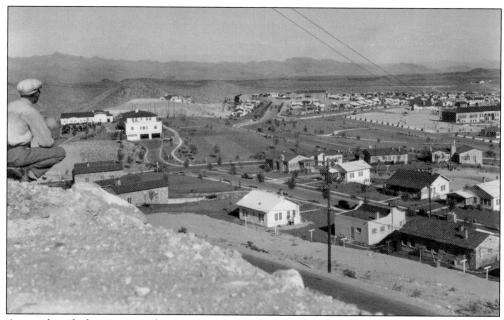

An unidentified man views the construction of Boulder City from Water Tank Hill. The street below is Denver Street, the USBR administrative headquarters and engineers' dormitory is on the left, and the Boulder City School (now city hall) is in the center right. (USBR photograph, courtesy of UNLV.)

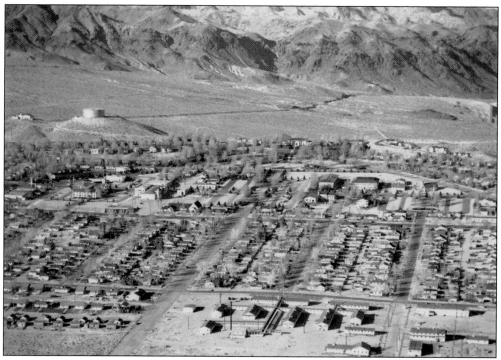

Saplings planted a decade earlier provided welcome shade by 1943. This aerial photograph reflects Boulder City's triangular design and the town's central focus—the USBR administrative building and annex at the north end of town. (Courtesy of UNLV.)

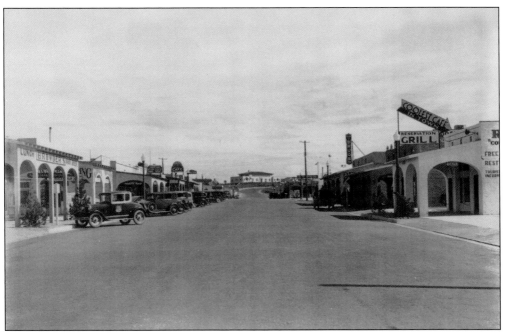

This early-1930s view of the Boulder City business district, looking north toward the USBR administration complex, shows Ida Browder's café on the left. Her business was one of the first commercial enterprises in town. The Austrian-born proprietor was also involved in local politics. (Courtesy of BCMHA.)

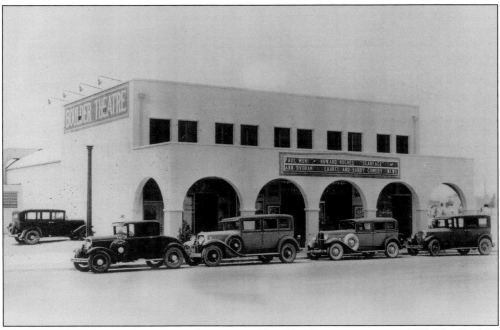

The Howard Hughes production *Scarface* attracted Boulder City moviegoers in 1932. The Boulder City Theater showed new releases and was the only air-conditioned business in town. Desperate to cool off, dam workers often purchased movie tickets and slept in the theater for most of the night. (Courtesy of USBR.)

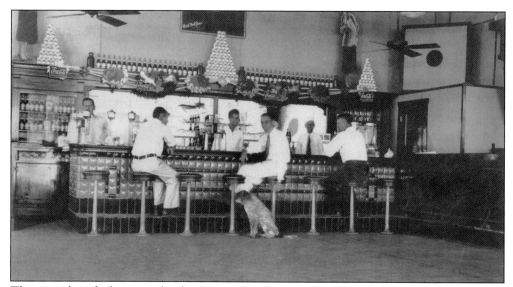

Three unidentified men and a dog sit at a lunch counter in the Boulder City Commissary, above Anderson Brothers Mess Hall. The store was run by Six Companies Inc., the prime contractor at the dam, and only accepted scrip, a type of currency issued as an advance of wages. (Courtesy of UNLV.)

Japanese immigrant Yonema "Bill" Tomiyasu owned a farm in Las Vegas near the intersection of Pecos and Sunset Roads. He delivered produce to restaurants in Jean, Searchlight, Goodsprings, and Beatty. He was hired to deliver fresh produce to Six Companies Inc.'s mess halls, which served up to 6,000 meals a day. Tomiyasu is seen here with his two children in the 1920s. (Courtesy of UNLV.)

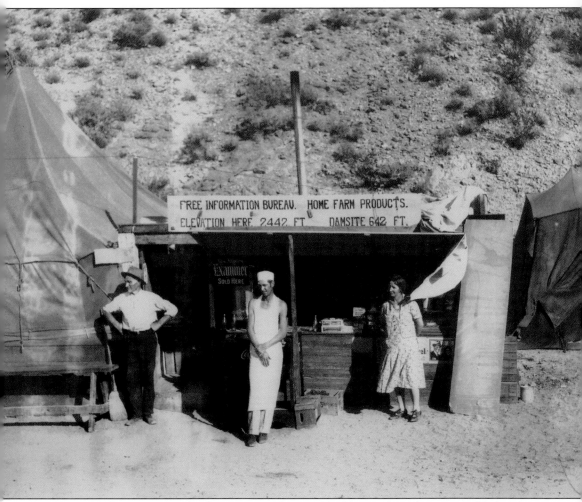

Boulder City's first grocery and café was opened by W.F. Shields in 1931 at the corner of Colorado Street and the truck route to the dam. Shields previously operated Hess's Camp at the base of Las Vegas Wash. In *Around Boulder City*, author Cheryl Ferrence names the Shields brothers as the first independents to run a food establishment on the federal reservation. By 1932, a total of 113 business licenses had been issued. (Courtesy of UNLV.)

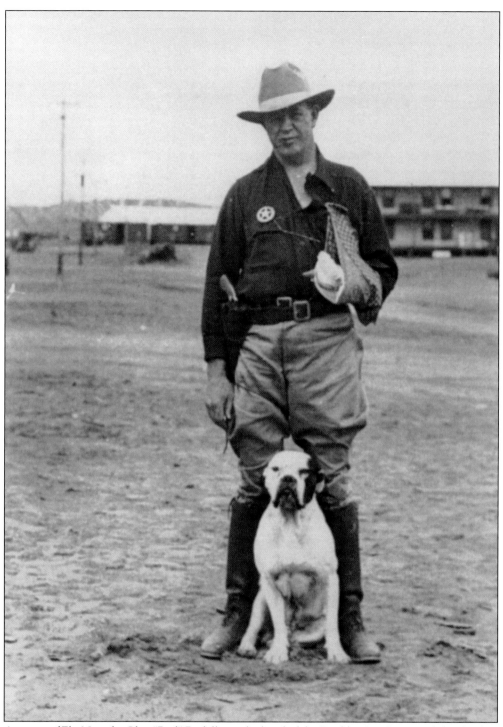

A native of Ely, Nevada, Glen "Bud" Bodell was the head of the Boulder City Rangers federal police force. In *Hoover Dam*, author Joseph Stephens describes Bodell as "physically and temperamentally suited to ruling with an iron fist." Posing with his bulldog, he is best remembered for running union organizers out of town after the 1931 strike. (Courtesy of BCMHA.)

Four

A Mega-Dam in Black Canyon

The USBR was eager to begin construction once the contract with Six Companies was signed. Still, extensive preliminary work had to be completed before the actual dam could be built. Two years would go by before the first dam footing could be poured. The initial thrust was on building Boulder City and new roads and railroads to transport construction materials, heavy equipment, and workers to the remote dam site. The State of Nevada helped by paving 24 miles of highway between Las Vegas and Boulder City. Diverting the river around the dam was second in importance to the dam itself. On May 12, 1931, work commenced on four underground diversion tunnels.

Excessive heat, unsafe working conditions, and rumored pay cuts for "muckers" led to employee dissatisfaction in the summer of 1931. Union organizers from the Industrial Workers of the World (IWW) had been biding their time and were ready to organize the workforce. But few workers signed up. Despite the hardships, they knew that 1,000 men wanted their jobs. Instead, workmen presented a list of requests to the Six Companies superintendent of construction, Frank Crowe, who responded immediately by closing down the project and firing most of the labor. Within a few days, the strike was broken and most of the men returned to work.

Lake Mead began to rise after the tunnels were plugged in the fall of 1934. The last concrete at the dam was poured on May 29, 1935. Six Companies completed the terms of its contract on February 29, 1936, and the federal government signed off on the work a few days later. President Roosevelt; Eleanor Roosevelt; the secretary of the interior, Harold Ickes; and a presidential entourage traveled by train to Boulder City for the dedication on September 30, 1935. Attention then turned to the powerhouse and artistic elements both in and on top of the dam.

The site of the dam had been narrowed to two options, one in Boulder Canyon and another in Black Canyon. The Black Canyon site had been staked by engineer Homer Hamlin years earlier. It was selected based on its superior geologic stability and its proximity to Las Vegas and the railroad. It also had less silt and debris than the Boulder Canyon site. The rock structure at Black Canyon was good, and the steep, narrow gorge would require less concrete than the Boulder Canyon site. (Courtesy of USBR.)

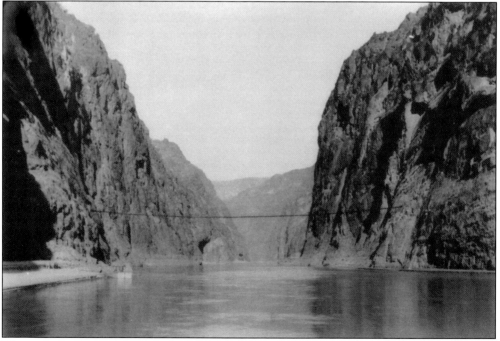

This upstream view of Black Canyon was taken in 1930, before construction. (Courtesy of USBR.)

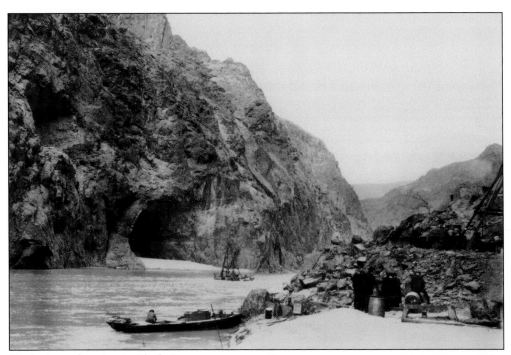

Geologic exploration in Black Canyon continued for years. Scientists were pleased when exploratory holes drilled 557 feet below the low-water line encountered a single brecciated volcanic rock formation, often called "Tuff of Hoover Dam." (Courtesy of UNR.)

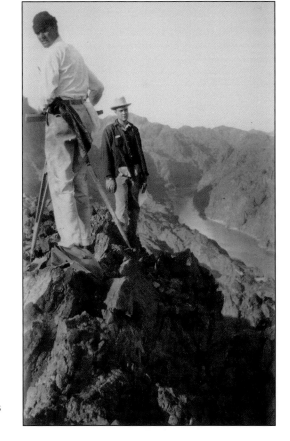

Congress appropriated the first $10 million to commence building Hoover Dam in July 1930. With the Depression already begun, the giant public works project would provide jobs to thousands of unemployed workers. The government moved quickly and completed an instrument survey of Black Canyon in less than six months. (Courtesy of UNLV.)

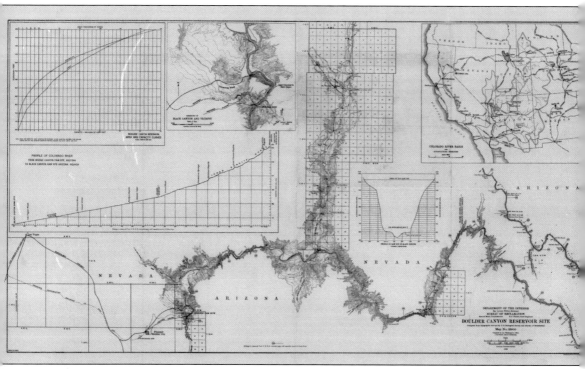

This 1930s USBR map reflects the pre–Hoover Dam landscape in this part of southern Nevada. (Courtesy of UNLV.)

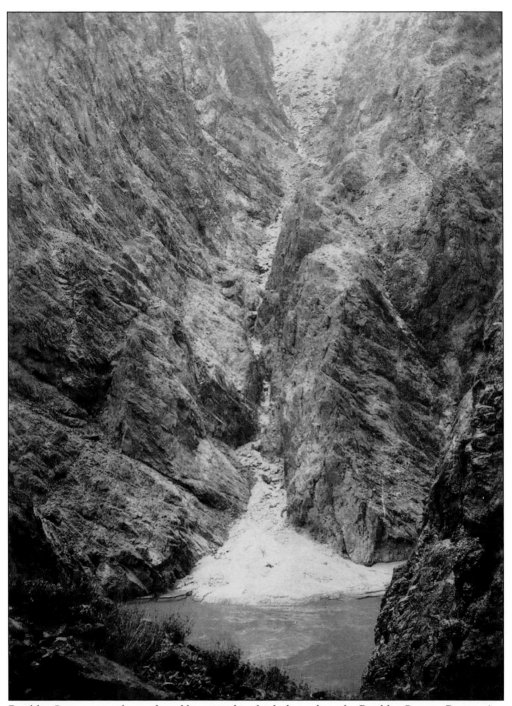

Boulder Canyon was the preferred location for a high dam when the Boulder Canyon Project Act was introduced in 1923. Boulder Canyon became synonymous with the project even through the dam was built in Black Canyon. (Courtesy of USBR.)

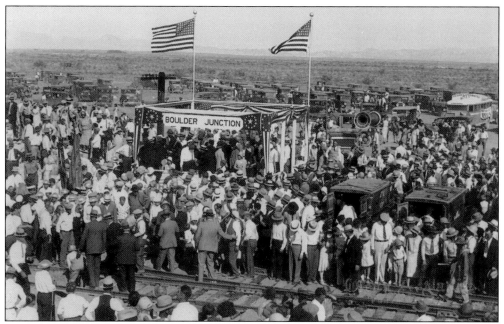

Ray Lyman Wilbur, the secretary of the interior, drove the silver spike at Boulder Junction on September 17, 1930, at the event that officially launched the Boulder Canyon Project. From here, the UPRR would lay 23 miles of track to Boulder City. Gov. Fred Balzar, US senators Key Pittman and Tasker Oddie, representative Samuel Arentz, and 10,000 onlookers were on hand for the ceremony. (Courtesy of UNLV.)

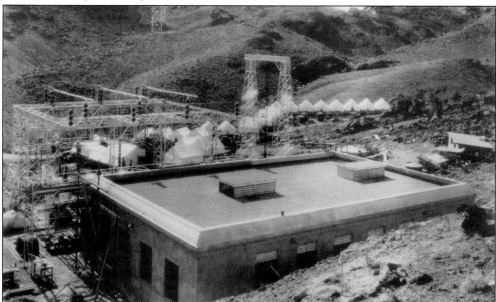

Electricity was transported over 235 miles of transmission line from Victorville to the Nevada-California Power Company substation above Black Canyon. The dam and Boulder City had electricity by April 1931. Construction crews lived in tents while building the substation. Several years later, the same transmission line was used to transport electrical power back to Southern California. (Courtesy of USBR.)

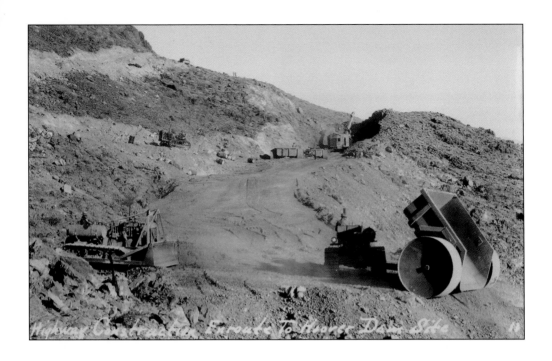

LeTourneau Construction had a reputation for being one of the most inventive and resourceful road builders in the nation. Still, navigating the volcanic outcroppings along the route to the dam (above) caused major delays for the contractor. Below, a vehicle is parked on the side of the completed highway on December 31, 1931. (Above, courtesy of UNR; below, courtesy of USBR.)

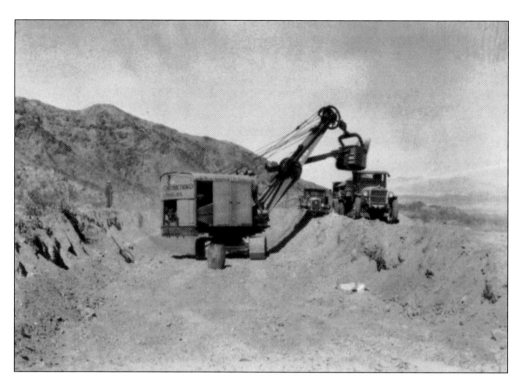

Lewis Construction Company laid slightly more than 10 miles of track from Boulder City to Black Canyon, and bored five tunnels, totaling 1,400 feet in length, through solid rock. Above, a new Thew-Lorrain shovel excavates the grade on February 25, 1931. Below, a portion of the finished grade is shown in front of Tunnel 3. (Above, courtesy of USBR; below, courtesy of UNR.)

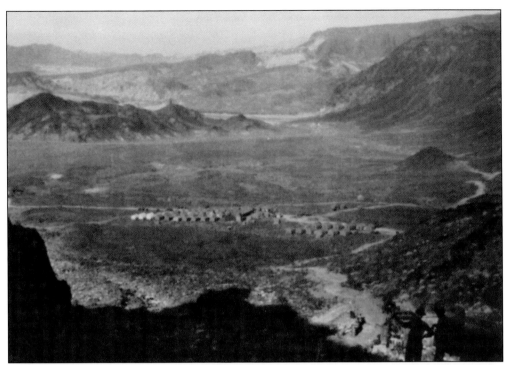

Lewis Construction Company, the builder of the US Construction Railroad, established this construction camp in Hemenway Valley, near the rail project. (Courtesy of USBR.)

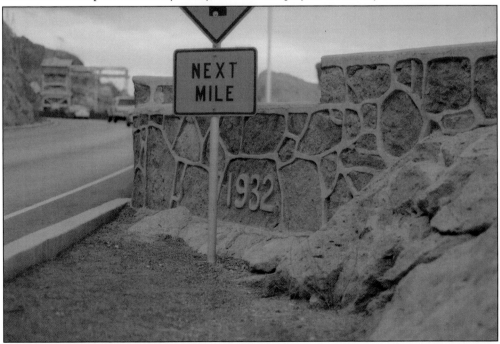

Retaining walls were built with natural rock and mortared exterior seams. Rock walls were built along most roads entering the dam and in switchyards. This segment on the Nevada side bears the construction date 1932. (Courtesy of LOC, Historic American Engineering Record [HAER].)

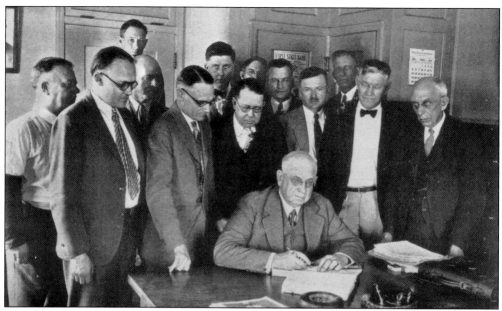

USBR commissioner Dr. Elwood Mead (seated) and chief engineer R.F. Walter sign the Six Companies Inc. contract in March 1931. (Courtesy of USBR.)

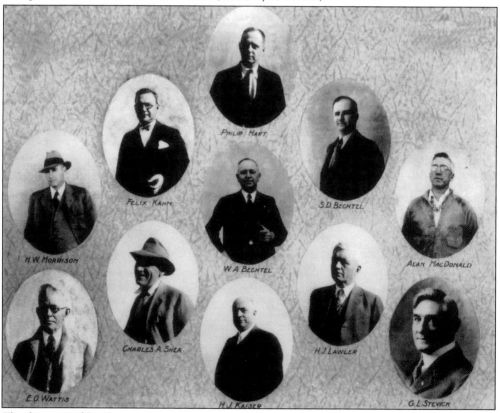

The directors of Six Companies Inc., a consortium of contractors from around the West, are seen in this collage. (Courtesy of USBR.)

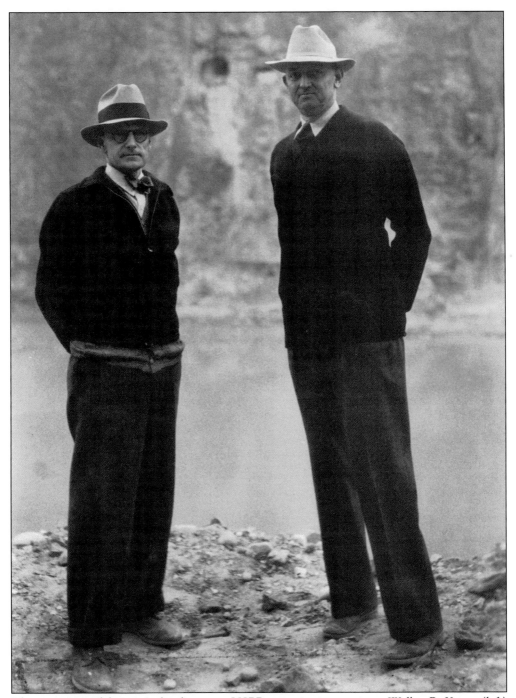

The most powerful men at the dam were USBR construction engineer Walker R. Young (left) and Six Companies Inc.'s general superintendent, Frank T. Crowe. Young represented USBR's interests, and "Hurry Up" Crowe, as he was called by workers, implemented the Six Companies contract on-site. (Courtesy of USBR.)

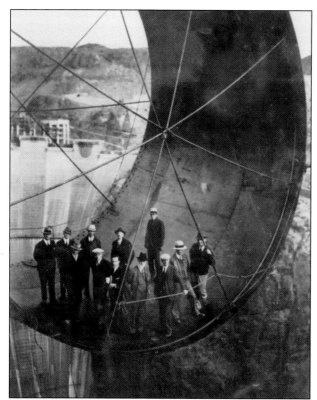

Officials from USBR, employees of the Babcock Wilcox Company, and members of the Boulder Consulting Board are suspended above the canyon inside a 30-foot-diameter penstock pipe on January 5, 1935. The Boulder Consulting Board was a respected group of hydrologists, geologists, and engineers who recommended Black Canyon over Boulder Canyon, several miles upstream, for the dam site. (Courtesy of USBR.)

Ray Lyman Wilbur, secretary of the interior, made numerous visits to Hoover Dam during construction. He is seen here during an inspection of the dam site on July 15, 1931. (Courtesy of USBR.)

A somber President Hoover inspected the dam for the first and last time shortly after his defeat by Franklin Roosevelt. He is seen here inside Tunnel 2 on November 12, 1932. (Courtesy of USBR.)

This *Los Angeles Times* illustration characterizes the ongoing debate over the name of the dam. While Secretary Wilbur called it "Hoover Dam," his successor under President Roosevelt, Harold Ickes, preferred to call it "Boulder Dam." The latter name stuck until 1947, when Congress officially named it Hoover Dam after the former president. (Courtesy of USBR.)

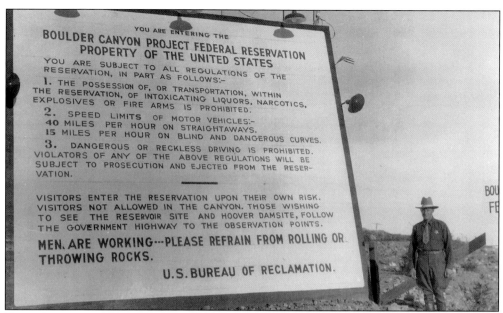

New rules were established for the influx of tourists who came to watch the dam being constructed. Safety measures considered both visitors and workmen. (Courtesy of UNR.)

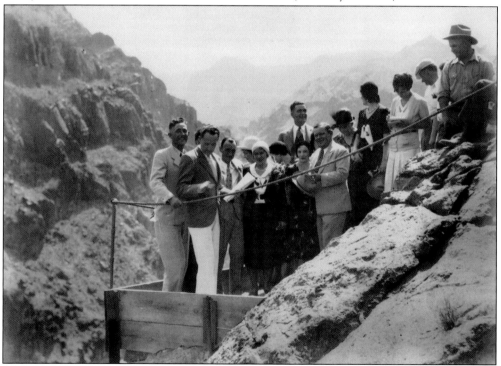

The September 1931 wedding of "Whataman" Hudson (holding the license) and Minnie "Ma" Kennedy (wearing the white hat) was the first nuptial at the dam. Kennedy was an evangelist and the mother of Aimee Semple McPherson, the founder of Foursquare Church. Guests included Las Vegas mayor E.W. Cragin, district attorney Harley A. Harmon, and Boulder City police chief Glen "Bud" Bodell. (Courtesy of UNLV.)

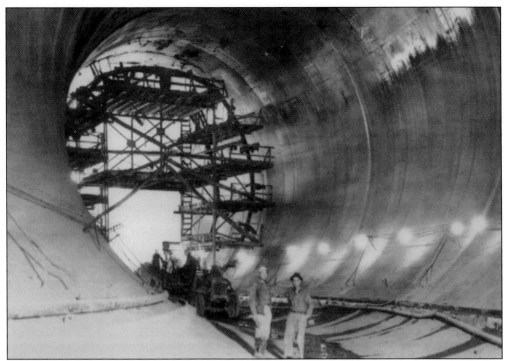

This view of the intake portal of Tunnel No. 4 was taken on September 6, 1932. The three-story truck-mounted rig, known as a "Jumbo," was built specifically for use in the diversion tunnels. The term "Jumbo" was used when a large piece of equipment had no other name. Men in this Jumbo are pressure-grouting the area behind the three-foot-thick concrete tunnel lining. (Courtesy of USBR.)

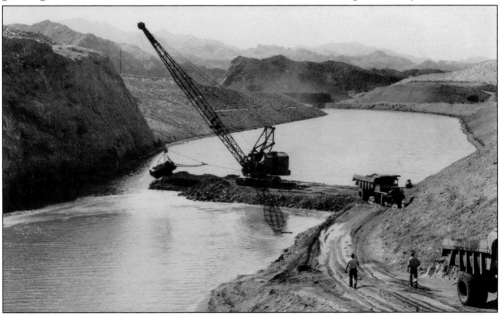

A coffer, or temporary dam, was built upstream of the dam to divert water into the tunnels. Another was built downstream, below the dam, to keep the construction site dry and workable. (Courtesy of USBR.)

Employees who lost their jobs in the August 1931 strike linger at the federal reservation gate east of Railroad Pass, waiting to be rehired. Following the strike, passes were required to enter Boulder City. (Courtesy of USBR.)

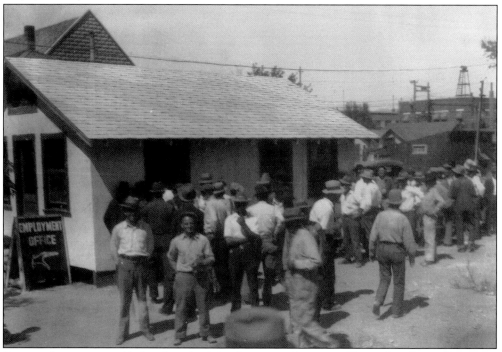

Dam workers were usually hired at the federal-state employment office in Las Vegas. Desperate men were known to register under several names to increase their chances of being selected. (Courtesy of UNLV.)

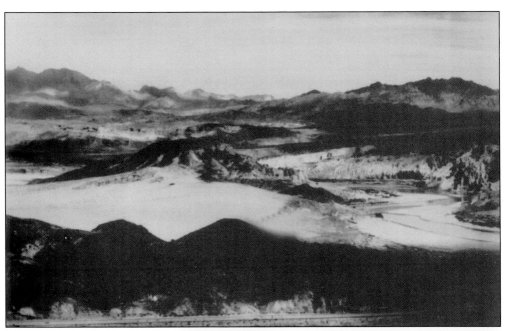

This panorama shows Hemenway Wash, which would soon be inundated by the Hoover Dam's reservoir, Lake Mead. The range of hills in foreground was submerged, and the hill in the right center became a small island. Ragtown can be seen in the lower right corner. The photograph was taken from Look Out Point on the road to Hoover Dam. (Courtesy of USBR.)

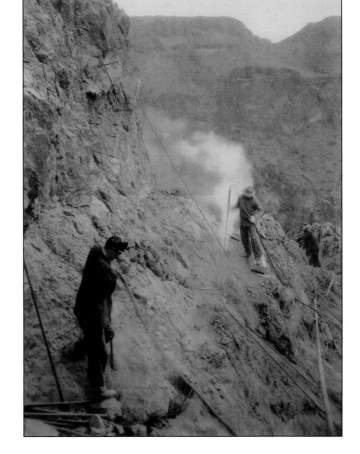

Rock surfaces had to be clean before concrete could be poured. These workmen with jackhammers scale loose rock from the spillway on the Nevada side of the canyon on February 11, 1932. (Courtesy of UNLV.)

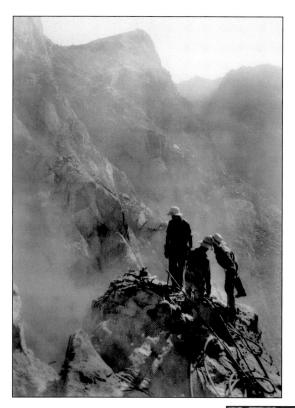

High-scalers prepare to scale the canyon wall near the penstocks from a 1,000-foot bench. The men are preparing their anchorage and ropes on August 22, 1932. Their job was to remove loose rock and scale back protrusions marked by the engineers. (Courtesy of UNLV.)

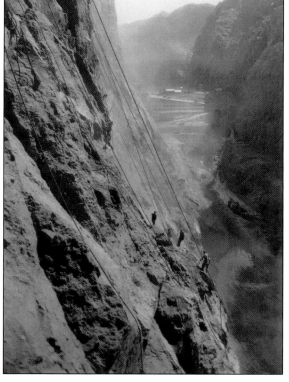

High-scalers descend a steep cliff on May 4, 1933. In his Boulder City Library oral history, Joe Kine describes high-scaling as a "sitting down job" and as one of the safest at the dam. Still, seven of the 400 high-scalers lost their lives. A bronze statue of Kine was recently erected at the visitor's parking garage. (Courtesy of UNLV.)

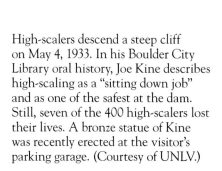

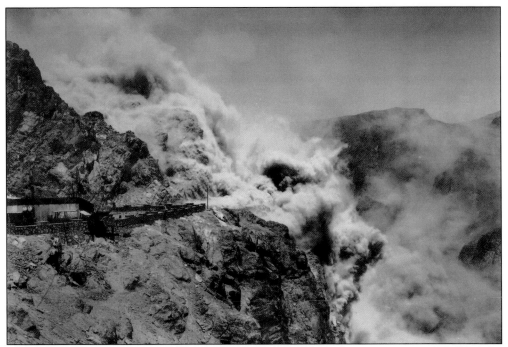

High-scalers drilled holes for dynamite. Blasting usually occurred at 12:30 a.m. and filled the entire canyon with dust. Las Vegas office equipment owner George "Bud" Albright was kept busy cleaning and repairing Six Companies' dust-clogged office machines. (Courtesy of UNLV.)

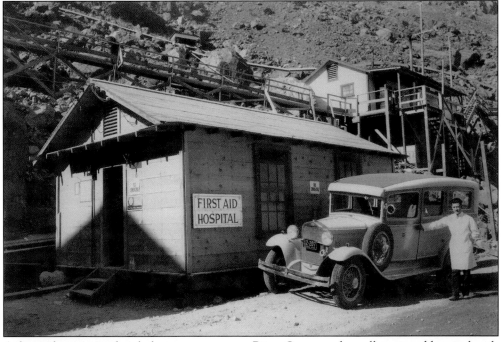

A first-aid station and ambulance was set up at River Camp, and a well-equipped hospital with an experienced surgeon and two other doctors was eight miles away in Boulder City. (Courtesy of UNLV.)

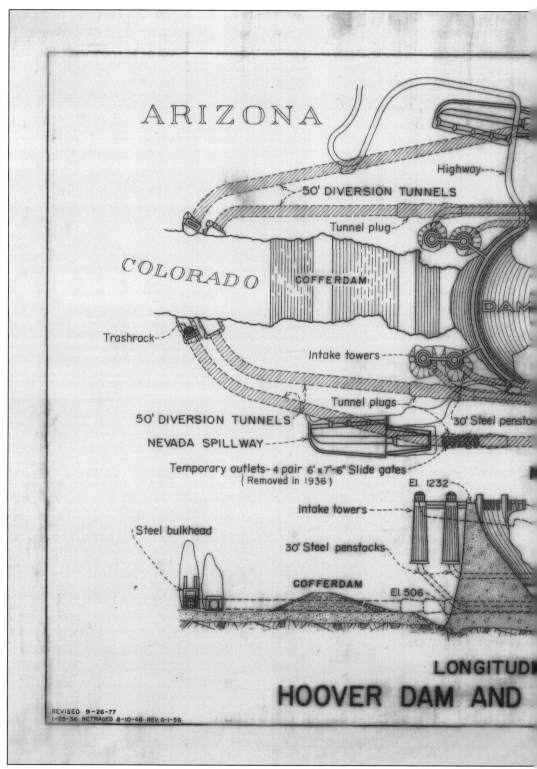

ARIZONA

Highway

50' DIVERSION TUNNELS

Tunnel plug

COLORADO

COFFERDAM

DAM

Trashrack

Intake towers

Tunnel plugs

50' DIVERSION TUNNELS

NEVADA SPILLWAY

30' Steel pensto

Temporary outlets- 4 pair 6'x7'-6" Slide gates
(Removed in 1936)

El. 1232

Intake towers

Steel bulkhead

30' Steel penstocks

COFFERDAM

El. 506

LONGITUD

HOOVER DAM AND

REVISED 9-26-77
1-25-36 RETRACED 8-10-48 REV. 6-1-56

This 1937 USBR drawing, *Hoover Dam and Appurtenant Works with Longitudinal Sections*, shows

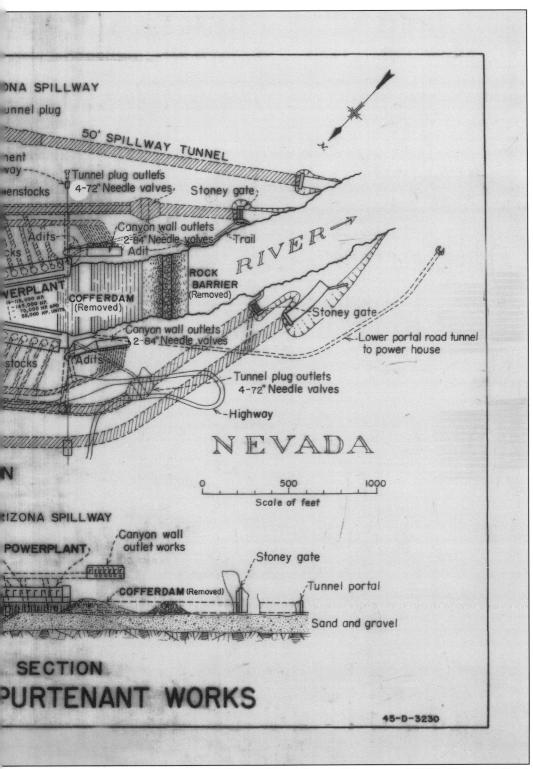

50' SPILLWAY TUNNEL

Tunnel plug outlets
4-72" Needle valves

Stoney gate

Canyon wall outlets
2-84" Needle valves

Trail

Adits

Adit

RIVER

ROCK
BARRIER
(Removed)

OWERPLANT

COFFERDAM
(Removed)

Canyon wall outlets
2-84" Needle valves

Stoney gate

Lower portal road tunnel
to power house

stocks

Adits

Tunnel plug outlets
4-72" Needle valves

Highway

N E V A D A

0 500 1000

Scale of feet

RIZONA SPILLWAY

POWERPLANT

Canyon wall
outlet works

Stoney gate

COFFERDAM (Removed)

Tunnel portal

Sand and gravel

SECTION
PURTENANT WORKS

45-D-3230

the interconnected structures at the dam and powerhouse. (Courtesy of USBR, Denver Office.)

Waste rock and debris from the tunnels, excavations, and explosions were hauled by truck to the spoil piles on both sides of the dam. Trucks would have entered this tunnel from the lower portal road on the way to the large spoil piles. (Courtesy of LOC, HAER.)

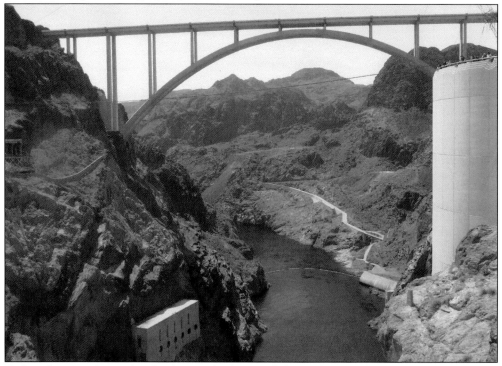

Today, the Nevada spoils piles (center background) look like large hills and blend with the landscape. (Author's photograph.)

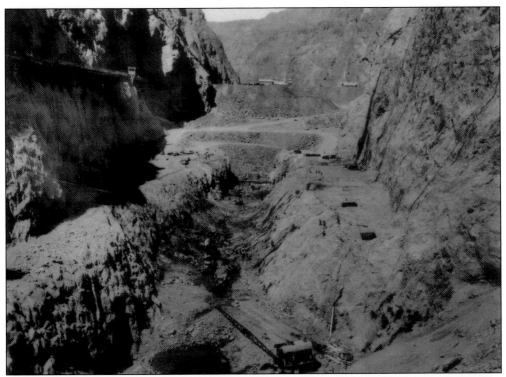

Workers perform a final cleanup after reaching bedrock below the riverbed in spring 1933. The actual dam construction could then proceed. (Courtesy of USBR.)

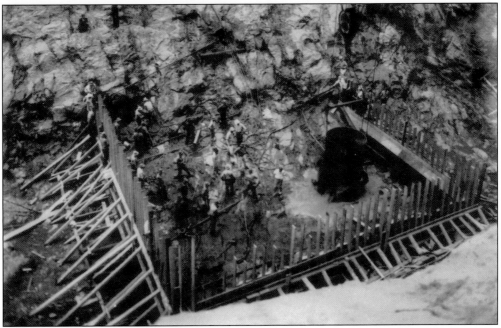

After two years of preparatory work, dam construction began. These "puddlers" are ready to spread the first bucket of concrete into wooden forms on June 6, 1933. Each bucket held eight cubic yards, or 16 tons. (Courtesy of USBR.)

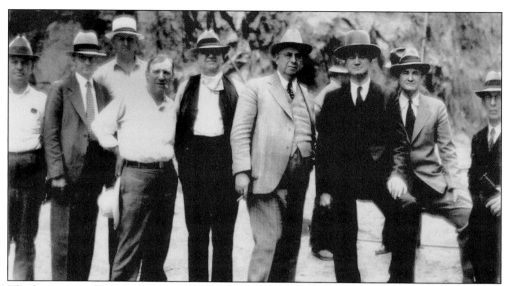

The long-awaited first pour of concrete was attended by, from left to right, H.J. Lawler, director, Six Companies; Walker R. Young, construction engineer, USBR; Frank T. Crowe, superintendent, Six Companies; C.A. Shea, director, Six Companies; W.A. Bechtel, director, Six Companies; R.F. Walter, chief engineer, USBR; Theodore A. Walters, from the secretary of the interior's office; and Ed Clark and C.P. Squires of the original Colorado River Commission. (Courtesy of USBR.)

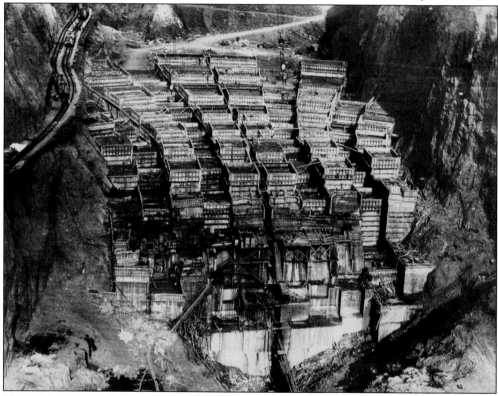

Hoover Dam was well underway by the time this photograph was taken in late 1933. (Courtesy of USBR.)

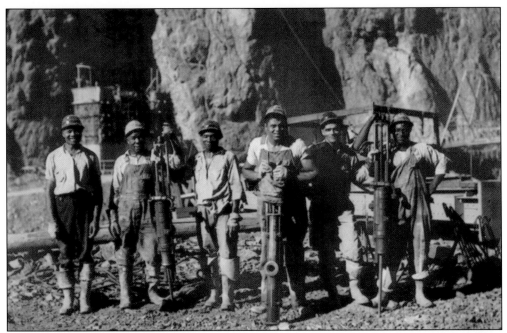

A small number of African Americans worked on Hoover Dam, although more would have liked to. In his Boulder City Library oral history, Glen "Bud" Bodell recalls one black laborer who died on the job. In a sign of the times, Boulder City manager Simms Ely prohibited blacks from living in Boulder City. (Courtesy of USBR.)

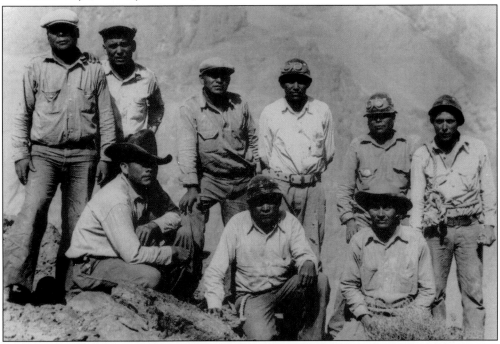

These Native American high-scalers, including a Yaqui, Crow, Navajo, and six Apaches, pose for this photograph on November 5, 1932. Some officials believed that Indian men were used to living in the desert and could easily adjust to the rugged workplace. (Courtesy of USBR.)

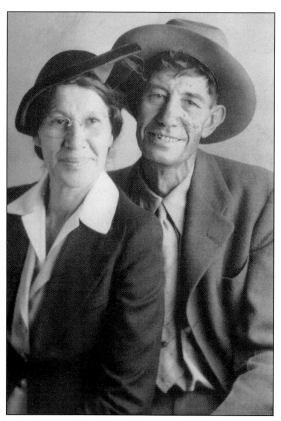

Members of the Chippewa-Cree tribe, William Nicholas DeLorme, his wife, Mary Louise La Rance DeLorme, and their seven children left Montana to come work at the dam. DeLorme was an experienced miner with valuable skills. Statistics on the number of Native Americans who worked on Hoover Dam are difficult to find. (Courtesy of Norman DeLorme.)

Here, concrete workers pack up their gear and head for home at the end of their shift on January 2, 1934. Working conditions were more pleasant in the middle of winter. Judging by their attire, it was probably chilly in the canyon once the sun dipped behind the canyon walls. (Courtesy of USBR.)

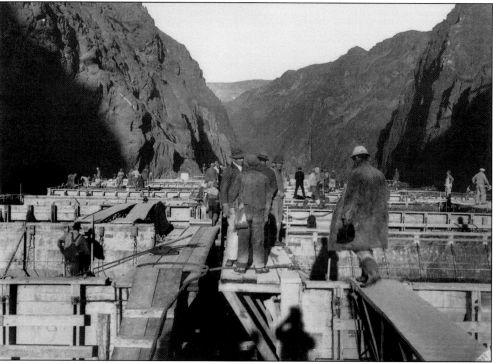

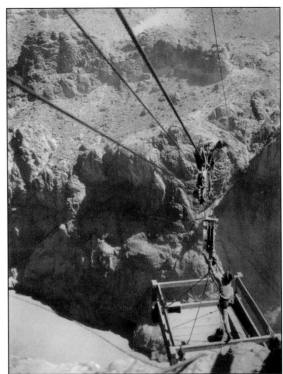

A temporary cableway (at right) ran from near Observation Point to the Arizona Spillway. Moveable cableway towers (below) moved along tracks overlooking the dam site on the canyon rim. Shown on April 13, 1932, the towers supported 150-ton-capacity cableways used to carry workers, concrete, and other materials to the work site. (Right, courtesy of UNLV; below, USBR.)

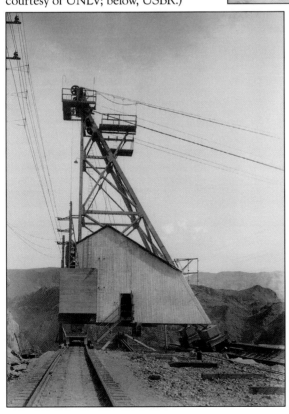

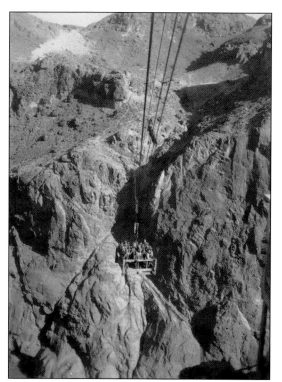

Skips were used to transport men across the canyon. In *Hoover Dam & Boulder City*, Marion Allen recalls a harrowing experience when a load of men was stranded 200 feet above the canyon. Some men prayed as their skip spun uncontrollably, and sparks rained down on workers whenever the operator moved it. After dangling for five hours, they were rescued by a skip on a jerry-rigged cableway. (Courtesy of UNLV.)

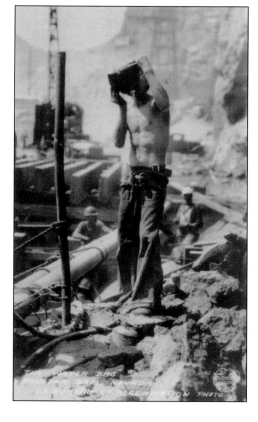

This Ben Glaha photograph of a thirsty dam worker drinking from a water bag came to epitomize the Hoover Dam Project. Merciless sun and heat radiated from the dark canyon walls and created temperatures of up to 120 degrees during the summer. There was no escaping the heat. Employees worked seven days a week with only four days off a year. (Courtesy of UNR.)

A second concrete plant called Himix was built closer to the dam. Fully automated, the plant could measure sand, aggregate, water, and cement, and mix 24 cubic yards of concrete in less than four minutes. The Lomix plant produced the concrete for the diversion tunnels and the base of the dam; the Himix plant made the concrete for the upper dam. (Courtesy of UNLV.)

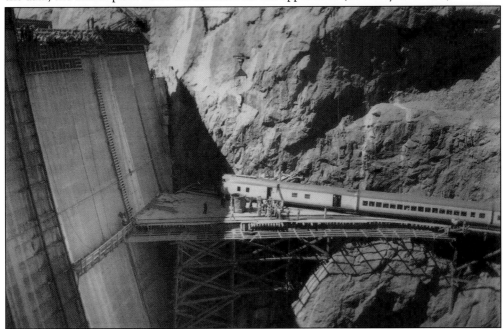

The UPRR's "Train of Tomorrow" arrived at the dam on March 9, 1934, during a publicity run. The streamlined Union Pacific M100 train was powered by a high-tech diesel-electric engine. Lomix trains normally delivered concrete to the dam over this spur. (Courtesy of UNLV.)

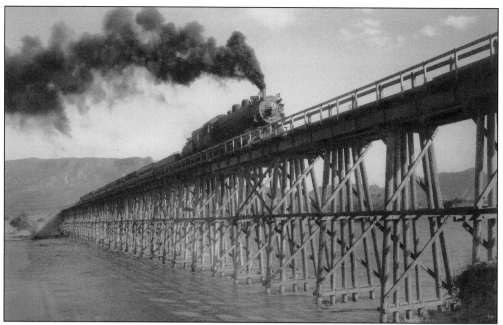

A train crosses the Colorado River on a 1,100-foot trestle while en route to a gravel-screening plant in Hemenway Wash. Six Companies built nearly 37 miles of standard-gauge railroad between Gravel Pit Station in Arizona, gravel storage and aggregate stations, and the dam site. Today, the majority of Six Company railroads and gravel plants are submerged under Lake Mead. (Courtesy of UNLV.)

Frank Crowe was a relentless taskmaster with little tolerance for delays. As a result, the dam was completed nearly two years ahead of schedule. The largely completed upstream face of Hoover Dam is seen here on January 2, 1934. (Courtesy of USBR.)

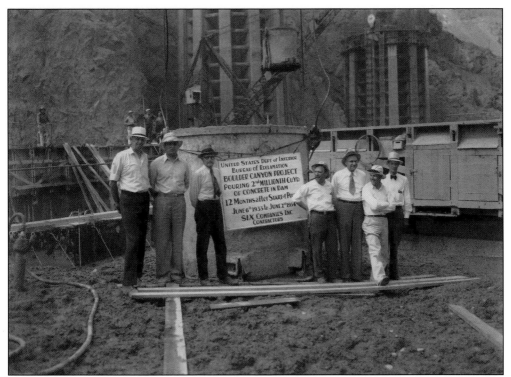

The second-millionth yard of concrete was poured at the dam on June 2, 1934. (Courtesy of UNLV.)

Due to the enormous size of the penstock pipes, the Babcock Wilcox Company fabricated them a mile and a half west of the dam. This view shows the US Construction Railroad and the US Construction Highway on the left. (Courtesy of UNR.)

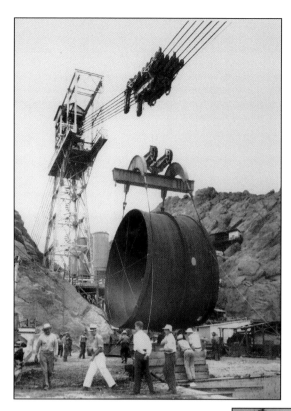

A government cableway lifts the first 30-foot-diameter section of penstock pipe from a specially built trailer on July 20, 1934. (Courtesy of UNLV.)

The Nevada Intake Towers are seen here under construction on July 20, 1934. Four towers—two on either side of the river—were built on rock shelves blasted from bedrock. When the powerhouse was completed, water would enter the intakes and flow through the penstocks to the turbines, which produced electric energy. (Courtesy of UNLV.)

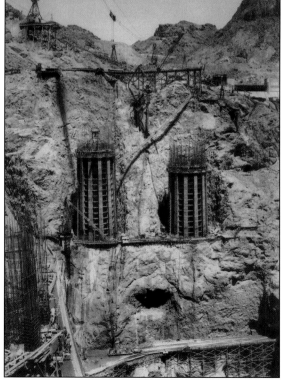

This general view of Hoover Dam was taken on December 13, 1935. (Courtesy of USBR.)

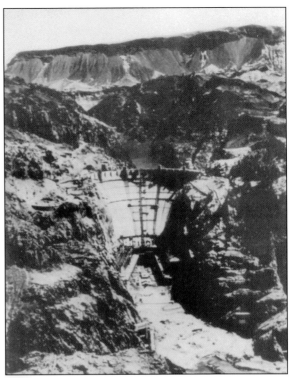

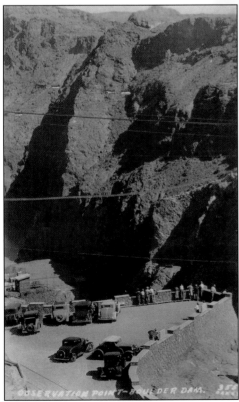

The second Observation Point was larger and bounded by a mortared rock wall to safely accommodate visitors and their vehicles. (Courtesy of UNR.)

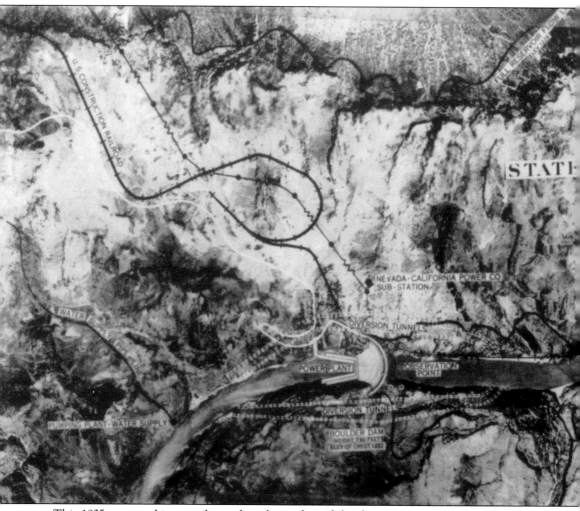

This 1935 topographic map shows the relationship of the dam, its appurtenant structures and ancillary features, and the natural landscape. Note the water pipeline to Boulder City on the left. (Courtesy of USBR.)

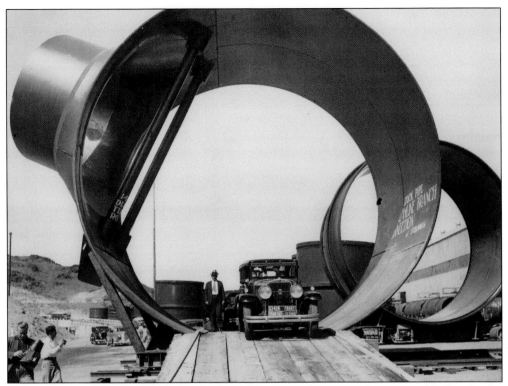

President Roosevelt's motorcade passes through a penstock pipe on the way to the dam for the dedication ceremony on September 30, 1935. USBR project engineer Walker Young sat between the president and the first lady, Eleanor Roosevelt, in an open-air motorcar. The president waved his straw hat at cheering crowds while touring Boulder City. (Courtesy of FDR Library.)

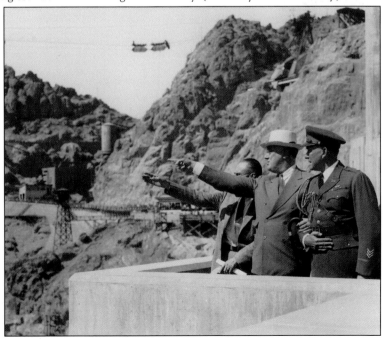

President Roosevelt is steadied by an Army aide while a USBR representative briefs the president on the workings of the dam. (Courtesy of FDR Library.)

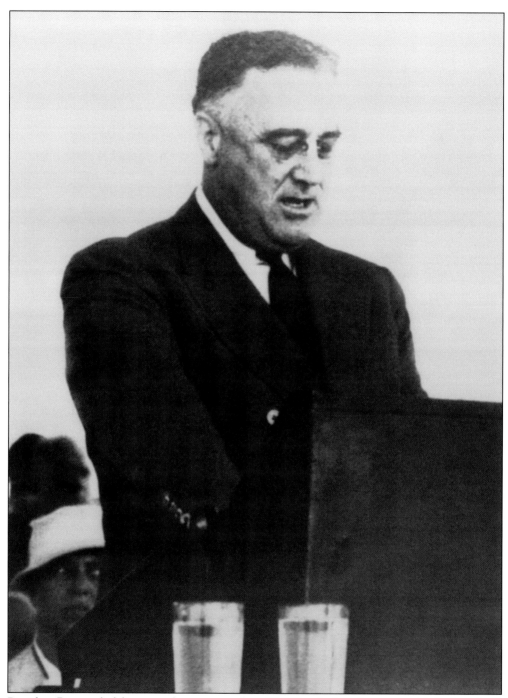

President Roosevelt delivers an eloquent speech to 20,000 onlookers from a special platform built for the occasion. First lady Eleanor Roosevelt sits behind the president. The president and first lady were given a tour of federally funded road projects on Mount Charleston before leaving Las Vegas. (Courtesy of USBR.)

Five

A SIGHT TO BEHOLD

Floyd Dominy, the USBR commissioner from 1959 to 1969, recalls, "I'll never forget January 2, 1937 . . . to stand down there on that transformer deck below the powerhouse, and look up at that massive chunk of concrete . . . And I marvel that anybody—*anybody*, could do such a thing . . . I had not the wildest idea that someday I would be in charge of that program."

The completion of the world's greatest engineering marvel became international news. Facts and figures on the record-breaking dam and the world's largest man-made lake went viral. The USBR used analogies to help the public grasp the project's magnitude. The 4.4 million cubic yards of concrete in the dam complex would pave a 16-foot-wide road from San Francisco to New York. Hoover Dam was also the first man-made structure to exceed the masonry mass of the Great Pyramid of Cheops at Giza. The 589-foot-deep lake was named after USBR commissioner Elwood Mead, who passed away in 1936. Its 32,359,274-acre-feet capacity would cover the state of New York with a foot of water.

Although the dedication was over, there was more work to be done. It would be three years before the architectural and aesthetic elements were completed. Elsewhere, the National Park Service was busy building recreation facilities and the Bureau of Fisheries raised and stocked game fish for anglers. Construction of the powerhouse generators, switchyards, and transmission lines moved ahead. The sale of power would pay for the dam. The City of Los Angeles' generators went on line in October 1936, and others were soon to follow. Seven switchyards would ultimately be constructed above Black Canyon. Power would be carried to Los Angeles, Chino, San Bernardino, Hayfield, and Needles in California; Pioche, Las Vegas, and Boulder City in Nevada; and Parker and Kingman in Arizona.

Meanwhile, the USBR shifted its attentions to the other components of the Boulder Canyon Act: the Imperial Dam and All-American Canal (AAC) to its south. The Colorado River Aqueduct was also started, and by the late 1930s, USBR would build Parker Dam and Lake Havasu to provide silt-free water for Southern California.

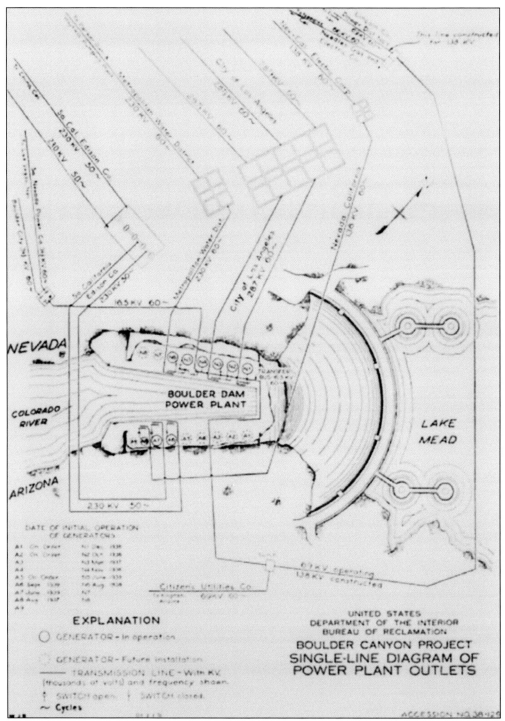

Hoover Dam was the largest producer of hydroelectric power in the country for more than a decade. Dedicated power produced by its generators was routed through circuits to the switchyards and carried over transmission lines to markets in California, Nevada, and Arizona. This drawing shows nine of the 17 generators in operation by the late 1930s. (Courtesy of USBR.)

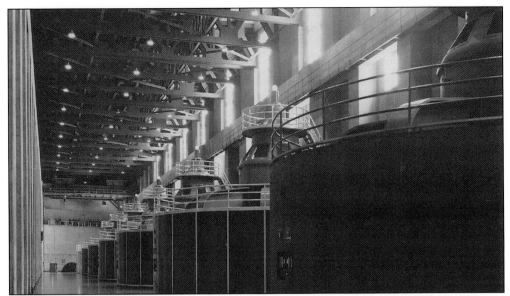

This is an early photograph of the generator gallery. Secretary of the Interior Wilbur authorized 50-year contracts with various utility companies. In 1987, the original contracts were renegotiated, and USBR took control of the power operations. Later, the Western Area Power Administration assumed this function. (Courtesy of USBR.)

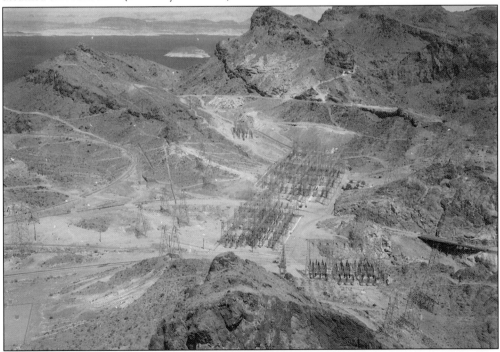

This aerial photograph shows six switchyards on the Nevada side of the dam in 1954. The switchyards were operated by the City of Los Angeles, Metropolitan Water District of Southern California; Southern California Edison (two switchyards); the Southern Sierra Power Company; and Nevada State. A seventh switchyard, run by the Citizen's Utilities Company of Kingman, was on the Arizona side of the river. (Courtesy of USBR.)

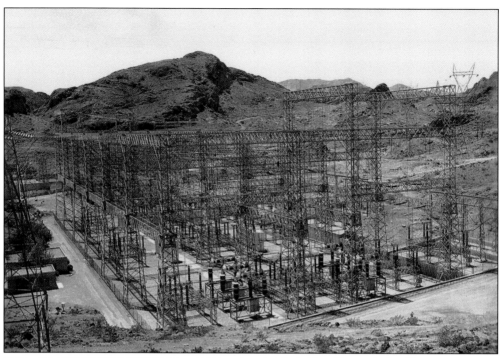

Transmission lines converge at the switchyards. The large switchyard pictured was operated by the City of Los Angeles in the late 1930s. By 1994, all of the original switchyards were bypassed. Today, Hoover Dam power is directed through the Mead Substation near Boulder City, where it is distributed to subscribers. (Courtesy of USBR.)

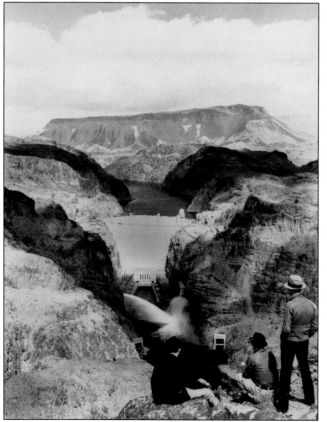

Three men look on as water from two 84-inch needle valves is discharged in 1938. The purpose of the needle valves is to bypass excess water around the dam and into the river during high water or when penstock pipes are emptied for maintenance. Fortification Hill, in the background, dominates the natural landscape. (Courtesy of LOC.)

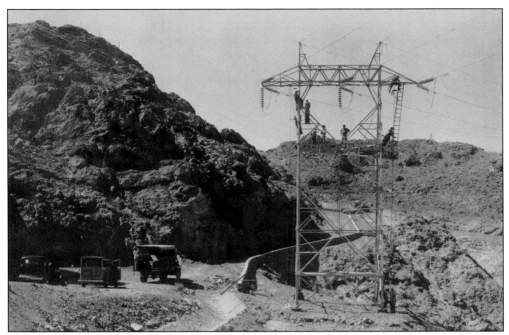

The Hoover Dam–to–Pioche, Nevada, transmission line tapped into a Citizens' Utilities Company of Kingman, Arizona, tower in 1937. Built by the Lincoln County Power District No. 1, the line cost $900,000 to build. Approximately $336,000 of that was financed by a Public Works Administration grant. The line carried power to mining districts in the Caliente and Pioche areas. (Courtesy of USBR.)

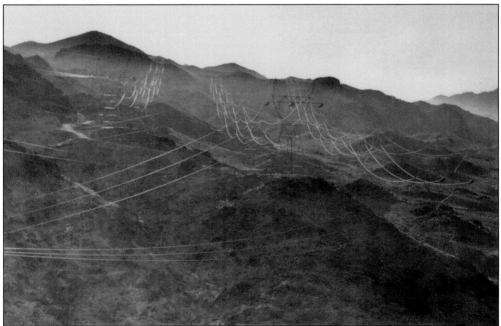

Rows of copper-and-aluminum transmission lines and giant lattice towers transport power across miles of desert to various Southern California destinations. Between 1935 and 1944, a total of 18 Hoover Dam transmission lines were constructed. (Courtesy of USBR.)

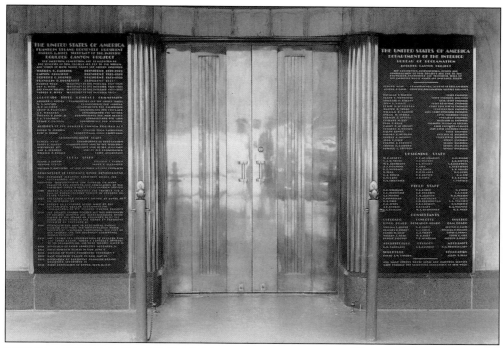

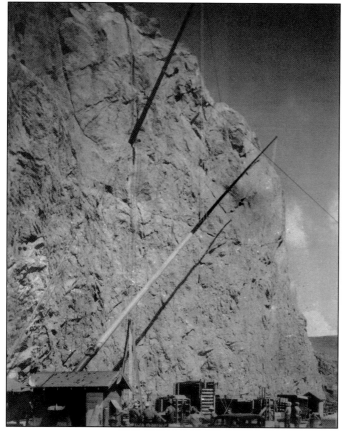

The simple lines of the solid brass elevator doors complement the dam's solid exterior. The doors are flanked by commemorative plaques honoring an extensive list of the professionals, appointed and elected officials, and agencies that made Hoover Dam possible. (Courtesy of USBR.)

The 142-foot flagpole was set into a polished black diorite base on September 23, 1937. The rock was obtained from a quarry in Santa Ana, California. Secretary of the Interior Harold Ickes wrote the inscription on the flagpole in honor of those who sacrificed their lives to make the desert fruitful. (Courtesy of USBR.)

Photographer Ben Glaha captured sculptor Oskar J.W. Hansen checking the *Circle of Precession of the Equinox showing the Platonic Year* on April 15, 1938. The design is a part of the terrazzo star map. (Courtesy of USBR.)

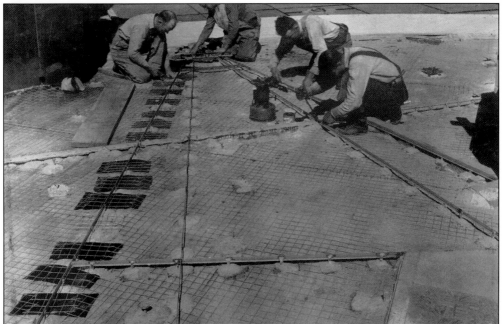

A new terrazzo technique using stretched steel piano wires was used to create the intricate patterns in the terrazzo star chart. These workmen lay out the design on March 31, 1938. (Courtesy of USBR.)

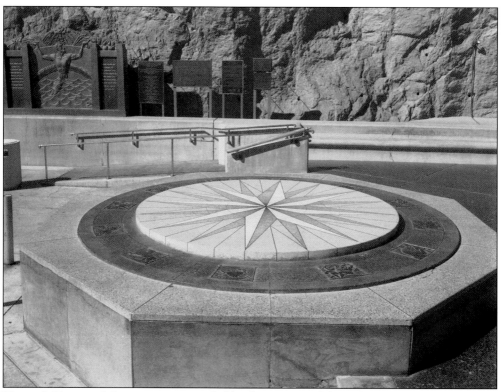

Hansen's Terrestrial Compass is surrounded by the 12 signs of the zodiac. The raised platform is set in a terrazzo base. (Courtesy of USBR.)

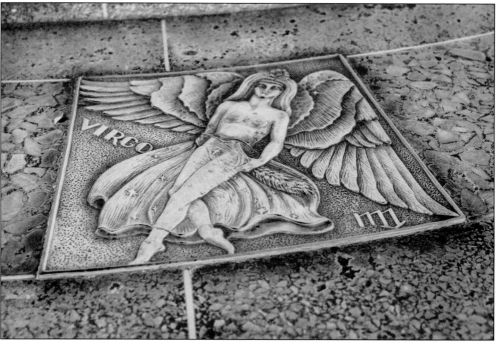

This brass plaque of Virgo is on the terrestrial compass. (Courtesy of USBR.)

Bas reliefs adorn the face of two elevator towers. On the Nevada side, the images depict the purposes of Hoover Dam; on the Arizona side, the reliefs depict the Indian people who lived in harmony with the land. (Courtesy of USBR.)

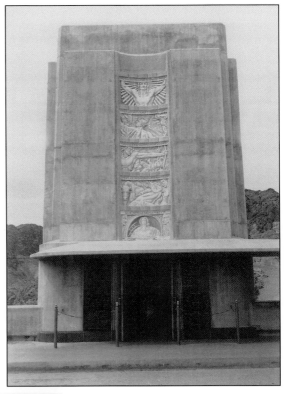

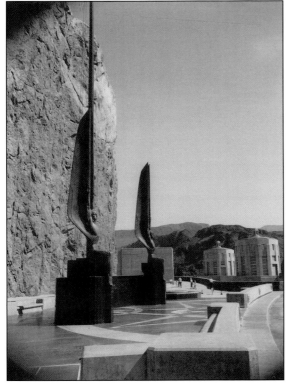

Two 30-foot-tall bronze statues, the *Winged Figures of the Republic*, stand guard over the American flag. The original sculptor, Oskar J.W. Hansen, personally supervised the refinishing of the statues in 1965. (Courtesy of USBR.)

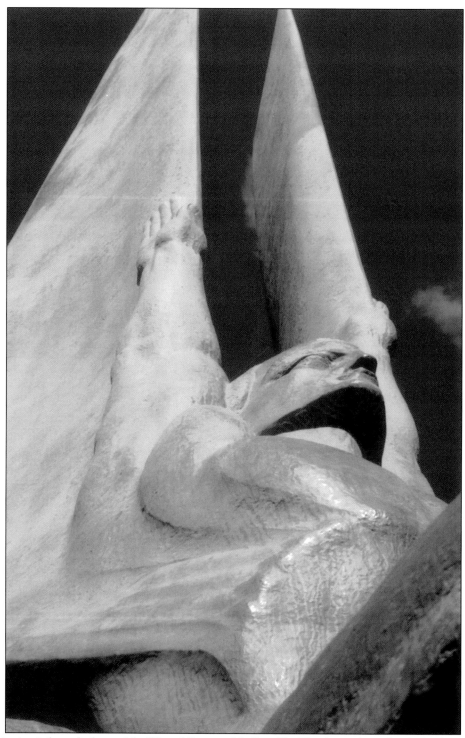

This view is from the base of the *Winged Figures of the Republic*. The figures bear the "look of eagles" and convey American vigilance and readiness to defend its institutions. (Courtesy of USBR.)

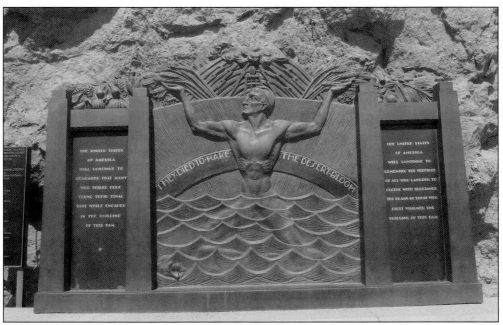

The memorial plaque honors those who lost their lives at the dam. The industrial death toll is cited at 96 or 112 including pre-construction fatalities. The USBR acknowledges 213 deaths from industrial causes—falls, explosions, rockslides, and vehicle accidents—*and* nonindustrial causes, like heat prostration, heart attacks, and illness. Unemployed and family members are included in the larger number. (Courtesy of USBR.)

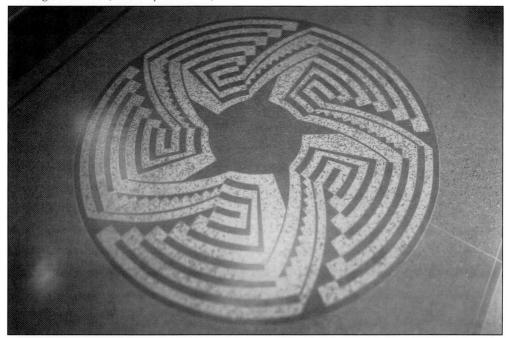

This Zuni-inspired pattern was set into the terrazzo floor in the powerhouse by trained Italian craftsmen. The geometric designs are centrifugal in nature to complement the generator rotations. (Courtesy of USBR.)

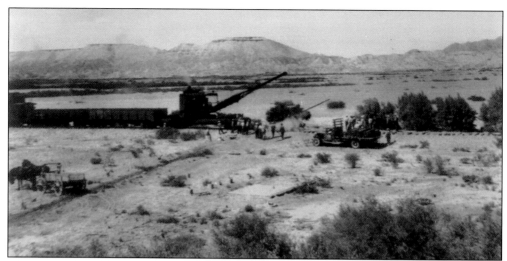

The Union Pacific Railroad salvaged six miles of track in the lower Moapa Valley before it was inundated by the rapidly rising lake. (Courtesy of Virginia "Beezy" Tobiasson.)

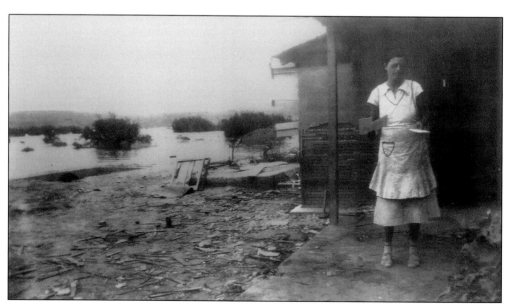

St. Thomas postmaster Leland Whitmore's wife, Maudean, holds the last postmarked mail at the facility. The post office closed on June 8, 1938. After completing their official duties, the couple was carried to dry land by boat. (Courtesy of Virginia "Beezy" Tobiasson.)

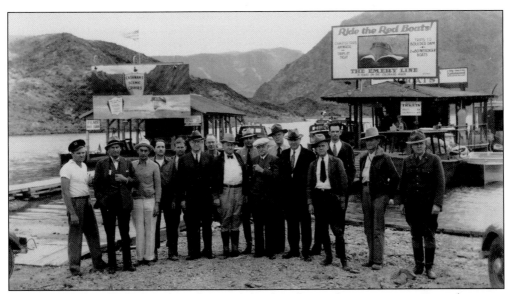

Nevada Congressman James Scrugham sought the advice of experts on ways to administer the new lake. This October 1935 upstream excursion was attended by, from left to right, Murl Emery, Robert Marsh, Paul. S. Webb, Harold S. Anderson, Edwin D. McKee, Randall Jones, Walter E. Seyfarth, James G. Scrugham, Charles Everett, B. M. Jacobsen, Colonel Thomas W. Miller, Captain H.S. Babbitt, M.R. Tillotson, George I. Collins, John Perkins, and Dr. Mark R. Harrington. (Courtesy of UNR.)

The Bureau of Fisheries (now the US Fish and Wildlife Service) planted fingerlings in Lake Mead in 1939. The reservoir was stocked with bass, bream, and trout. (Courtesy of LMNRA.)

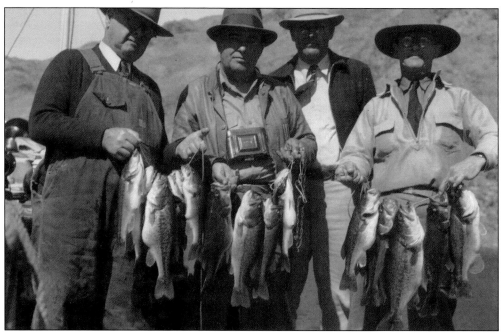

A group of fishermen shows off strings of wide-mouth bass caught in Lake Mead in 1938. (Courtesy of LMNRA.)

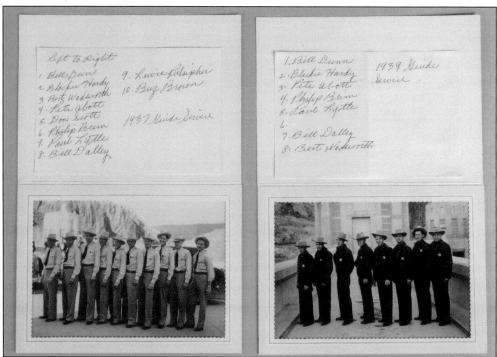

The USBR retained control of tourist facilities at Hoover Dam and initiated formal tours in 1937. Tour guides in starched uniforms are seen here in 1937 and 1939. In 1935, some 365,000 people visited the dam and lake. This number rose to 656,000 by 1940 and approached two million by 1950. (Courtesy of USBR.)

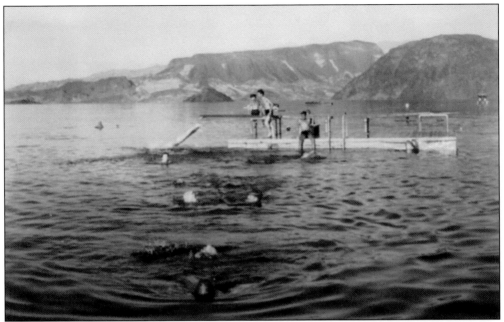

Residents and tourists cool off at Boulder Beach in Hemenway Wash in 1937. Camp Boulder City Civilian Conservation Corps enrollees manually removed rocks and leveled the surface to create a picnic area and a swimming area. (Courtesy of LMNRA.)

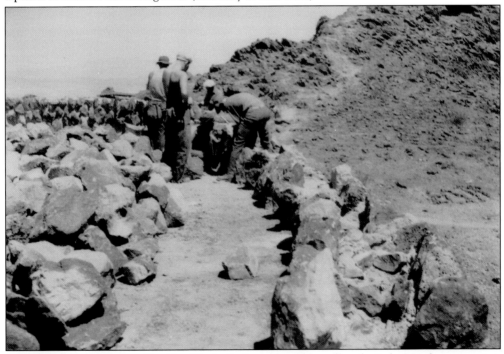

CCC enrollees from Camp Boulder City built the rock rubble wall at the Lake Mead overview just west of the Babcock Wilcox Company pipe fabrication shop (now a USBR warehouse) in 1937. From here, tourists enjoyed a spectacular view of the world's largest man-made lake. (Courtesy of USBR.)

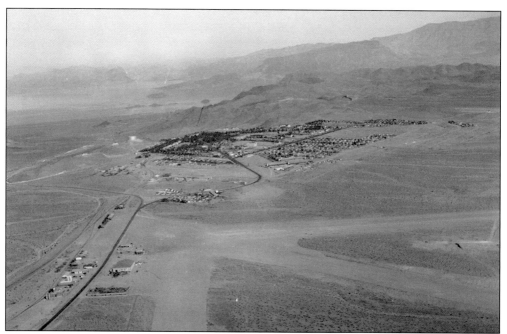

The CCC also graded the runways at the new Boulder City Airport. Grand Canyon Airlines and Trans World Airlines (TWA) added Boulder City to their flight schedules to facilitate the new tourist destination. Residents and dignitaries attended TWA's inaugural flight on April 3, 1938. (Courtesy of BCMHA.)

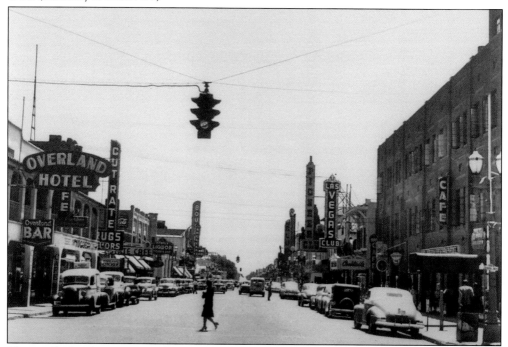

The small whistle-stop town of Las Vegas, 30 miles from Hoover Dam, grew and prospered as a result of several large federal projects, beginning with Hoover Dam. This photograph shows a bustling Fremont Street in the 1940s. (Courtesy of USBR.)

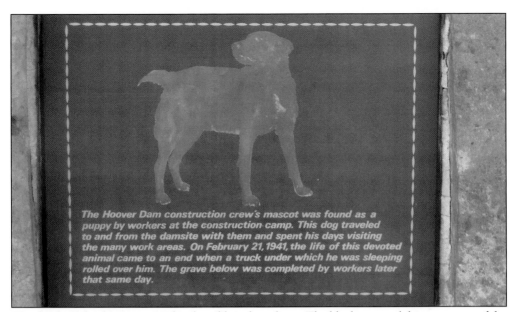

The death of the dam's mascot deeply saddened residents. The black mongrel dog was a part of the Hoover Dam work scene until he was accidentally run over by a truck in 1941. For years, he rode the bus to the dam, ate lunch with workers, and even rode the skips. He belonged to everyone but no one in particular. This monument was erected near where he died. (Author's photograph.)

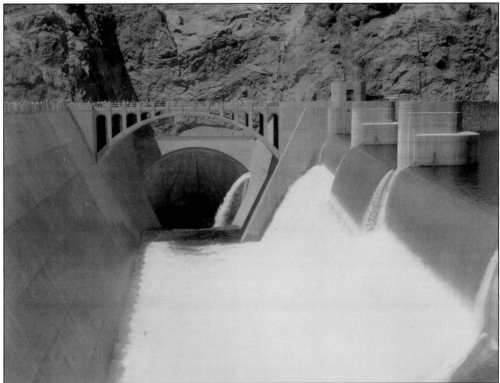

The Art Deco–style Arizona spillway was first tested on August 6, 1941, during high lake levels. (Courtesy of LMNRA.)

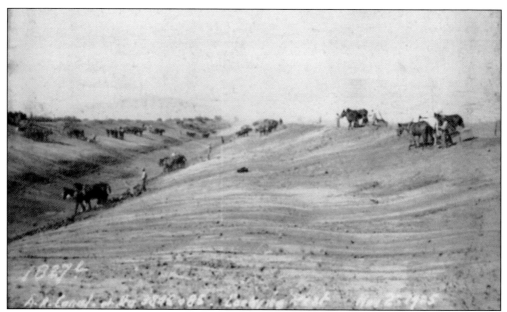

The All-American Canal (AAC) was part of the Boulder Canyon Project. The AAC services the Imperial and Coachella Valleys and the Yuma Project. Shown in 1935, the canal was dug by horses and fresnoes (scrapers) and draglines. The canal runs from the Imperial Dam, 18 miles north of Yuma, and skirts the international border to a point past Calexico, California. (Courtesy of IID.)

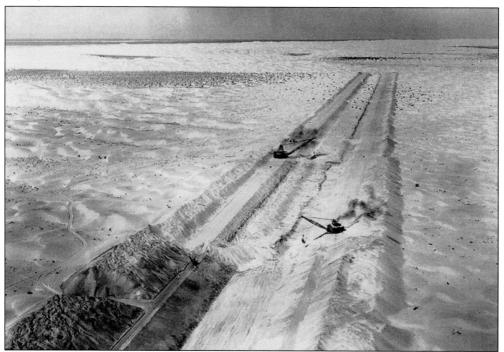

The builders of the AAC faced obstacles such as shifting and blowing sand and having to excavate the 160-foot-wide, 21-foot-deep channel through the Algodones Dune Fields. This photograph was taken in 1936 or 1937. (Courtesy of IID.)

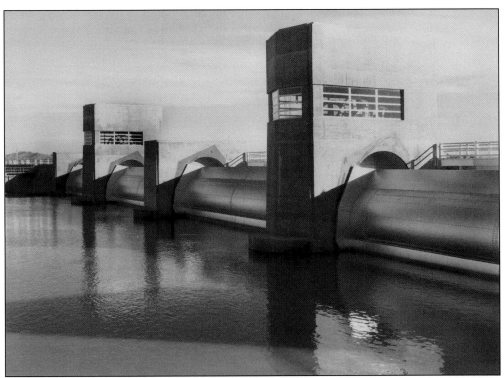

This view shows the Imperial Dam at the headgates of the AAC in 1939. The dam was built by some of the same Six Companies contractors that built Hoover Dam. (Courtesy of LOC.)

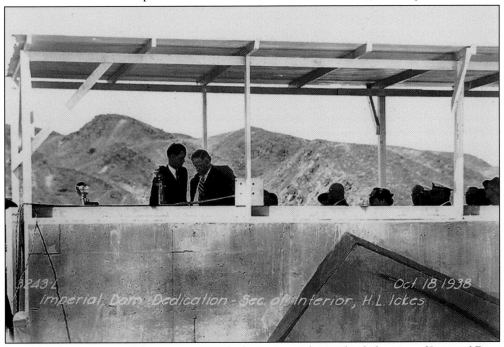

Harold Ickes, secretary of the interior, was the keynote speaker at the dedication of Imperial Dam on October 18, 1938. (Courtesy of IID.)

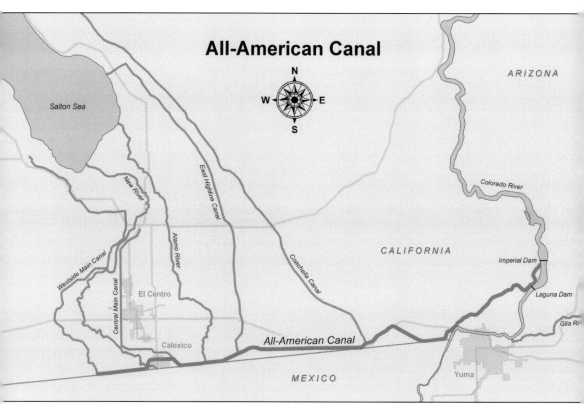

This map shows the All-American and Coachella Canals and their associated works, adapted from an IID drawing. (Courtesy of Bob Estes.)

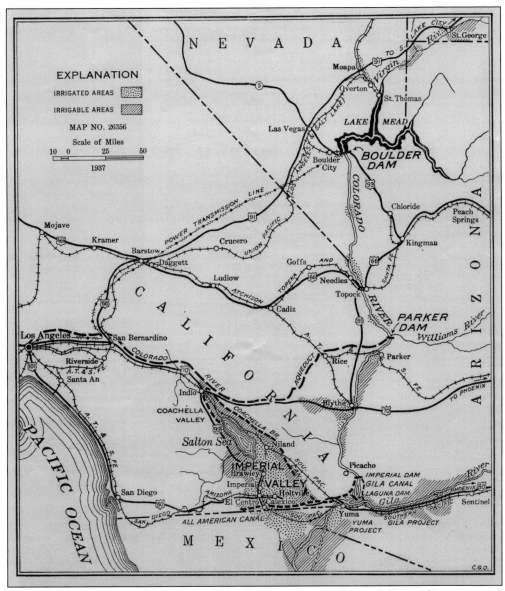

This USBR Boulder Dam brochure shows the dams, canals, aqueducts, and power lines in service or under construction in 1937. (Courtesy of Nevada Historical Society.)

The Coachella Canal branches off the All-American Canal 36 miles east of Yuma, Arizona, and carries water for 123 miles north to the Coachella Valley. Today, the Coachella Valley Water District operates the upper 74 miles of the canal while IID operates the lower 49 miles. (Courtesy of IID.)

Date palms thrive in Coachella Valley's warm climate and dry summers. Dates are also one of valley's most lucrative crops. By 1957, Coachella Valley made up 85 percent of the date acreage in the country. (Courtesy of IID.)

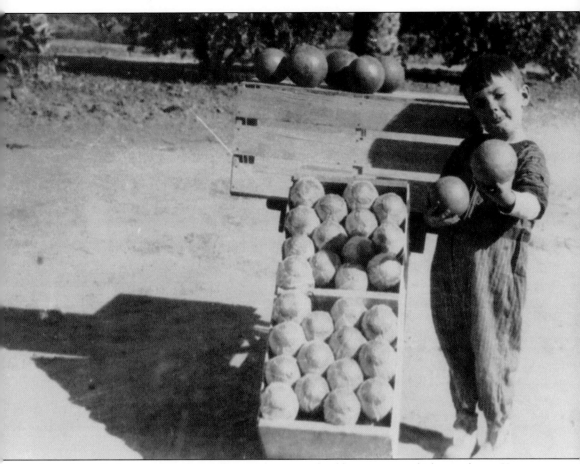

An unidentified young farm boy sells cantaloupes and cabbages at a roadside stand on a Yuma Project farm in 1938. Project waters were diverted from Laguna Dam and later from Imperial Dam. (Courtesy of USBR.)

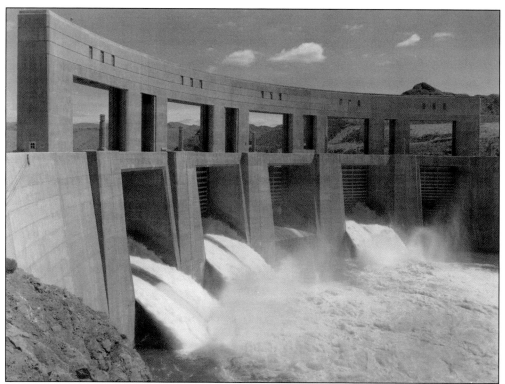

The LADWP and MWD needed Colorado River water to ensure the continued growth of the Los Angeles area. Completed in 1941, the Colorado River Aqueduct pumped water from behind Parker Dam (completed in 1938) and carried it through 242 miles of mountains and desert valleys before reaching Lake Matthews near Riverside, California. In 1955, the aqueduct was classified as one of the seven wonders of American engineering by American Society of Civil Engineers. (Both, courtesy of LOC.)

Many job-seekers arrived in California without a cent to their names. Such was likely the case for the Oklahoma family at right, whose vehicle broke down in the hot desert in 1937. Overwhelmed by the influx of unemployed migrants, California officials sought help from federal relief organizations. Below, unemployed men wait for relief checks in Calipatria in the Imperial Valley. (Both, courtesy of LOC.)

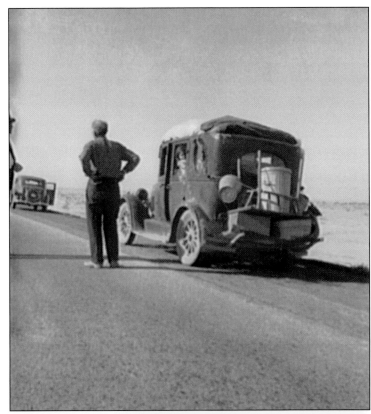

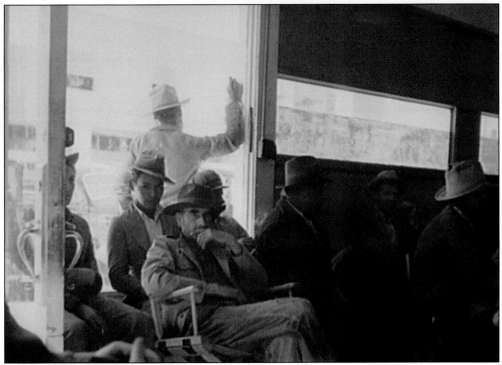

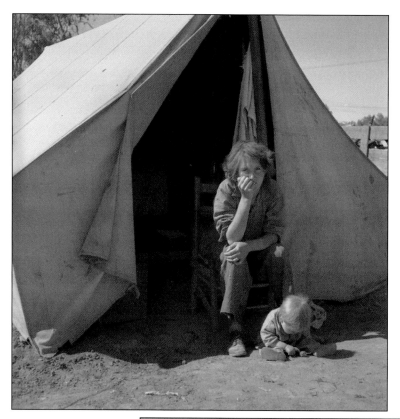

This young family lived in a hot tent with no running water or sanitation. Migrants often camped along ditch banks in Imperial Valley in order to have access to water. By necessity, the federal government built sanitary camps for health and humanitarian purposes. (Courtesy of LOC.)

Farmworkers toil in an Imperial Valley agricultural field in 1941. Fortunately, new opportunities became available to migrants with the onset of World War II. Most able-bodied men enlisted in the armed forces or were hired by Southern California defense contractors. (Courtesy of LOC.)

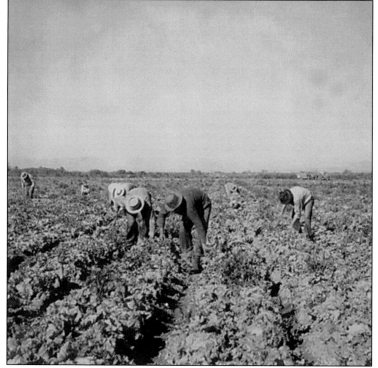

Six

WORLD WAR II AND THE POSTWAR YEARS

Hoover Dam had barely settled into a routine before it became a potential target for subversive activities. The powerhouse and transmission lines to Southern California and its defense plants were especially vulnerable. By 1939, escalating global conflicts and fears of sabotage forced dam officials to tighten security. The power plant was closed to the public and supervisors kept a watchful eye on employees. Before long, the War Department and FBI recommended additional security measures such as the banning of boats near the dam and the installation of wire netting behind the intake towers. Floodlights were installed upstream, and patrol activities intensified. In 1940, metal gates and guard stations were constructed at both approaches to the dam. Due to troop shortages, the War Department refused to guard Hoover Dam. Sen. Patrick McCarran responded by introducing a bill to establish a military presence on the reservation. In December 1940, the Army agreed to establish a temporary post with 800 troops in Boulder City.

Camp Williston soldiers guarded the switchyards, the water system, and the powder magazine, while USBR Rangers patrolled the powerhouse, the interior of the dam, and the federal reservation. Following the attack on Pearl Harbor in December 1941, unescorted traffic over the dam was stopped. Fears of suicide bombers led to blackouts. Dam windows were painted black and security lamps were turned off. In Boulder City, Lillian Morrison recalled that a blackout officer was assigned to her street to make sure all lights were out. After the Allies took control of the war, security was relaxed. The dam reopened on September 2, 1945.

Hoover Dam quickly rebounded and tourism resumed with new fervor. Boulder City expanded following the opening of the US Bureau of Mines (initially opened in 1936). The City of Los Angeles Bureau of Power and Light and California Edison built new homes for 200 employees. The USBR had planned to relinquish the reservation after the dam was completed, and despite opposition from some Boulder City residents, signed over 33 square miles to the newly incorporated Boulder City on January 4, 1960.

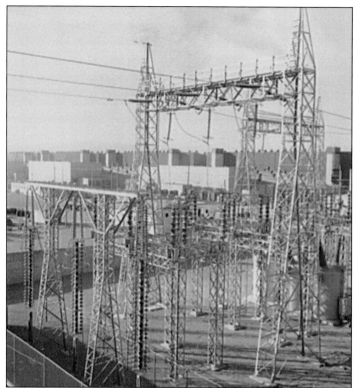

In 1943, approximately a quarter of Nevada's share of power from Hoover Dam was consumed by the Basic Magnesium Inc. (BMI) plant in Henderson, Nevada. The plant was one of the nation's largest producers of the light metals used for military aircraft and wartime needs. (Courtesy of LOC.)

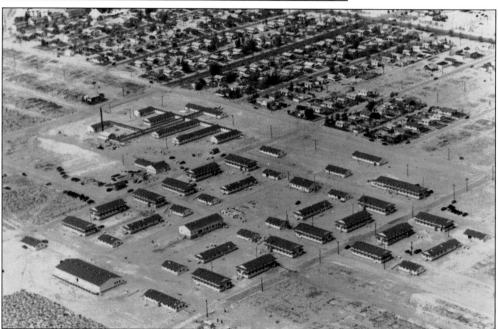

Camp Siebert was renamed Camp Williston when the Army realized that there was already a Camp Siebert. The cantonment was built in the desert at the south end of Boulder City. After the war, Camp Williston was dismantled and the buildings were moved to the Parker Dam construction camp. (Courtesy of BCMHA.)

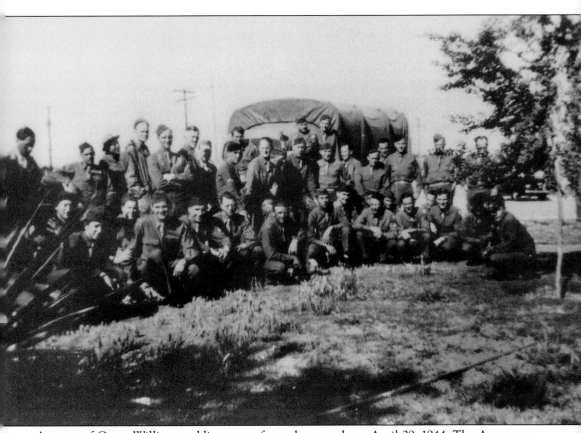

A group of Camp Williston soldiers poses for a photograph on April 29, 1944. The Army was in charge of perimeter guard duty and escorted motorists over the dam during World War II. (Courtesy of BCMHA.)

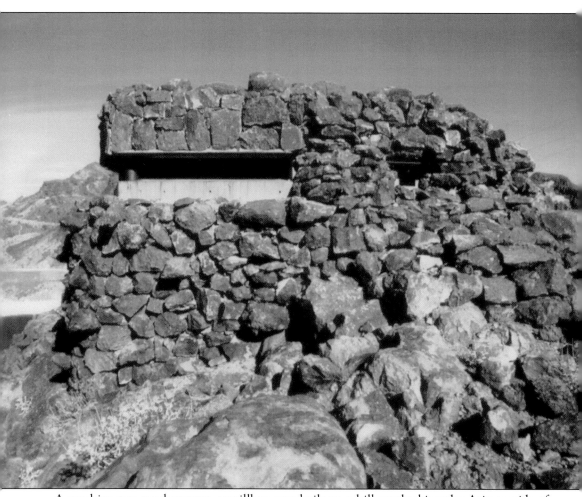

A machine gun emplacement, or pillbox, was built on a hill overlooking the Arizona side of Hoover Dam. The Army guarded the dam and the Kingman Highway from this location. The structure was recently restored. (Courtesy of USBR.)

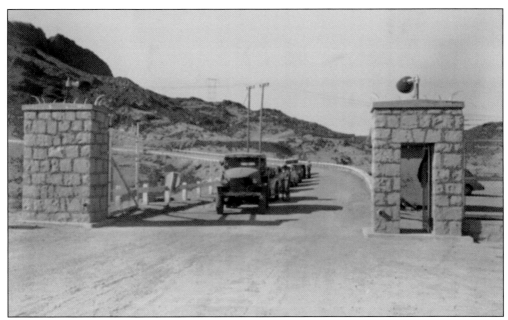

The dam was closed to visitors after the attack on Pearl Harbor on December 7, 1941. Civilians wishing to enter Arizona lined up at the Nevada gate. Army soldiers escorted up to 10 vehicles at a time, with a command car in the lead and another following behind the convoy. Stone pillars and metal gates were installed on both sides of the dam in the late 1930s to guard against sabotage. (Courtesy of USBR.)

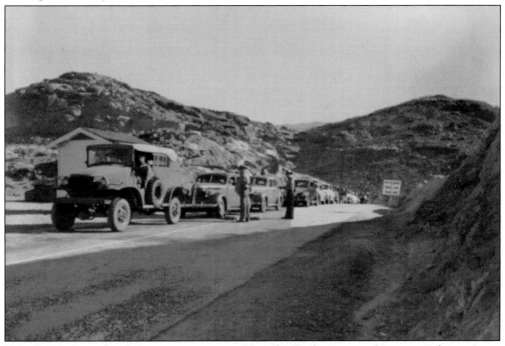

Travelers wait at the Arizona gate to enter Nevada. Each command car carried two Army escorts armed with Springfield, Garand, and Browning automatic weapons and side arms. (Courtesy of USBR.)

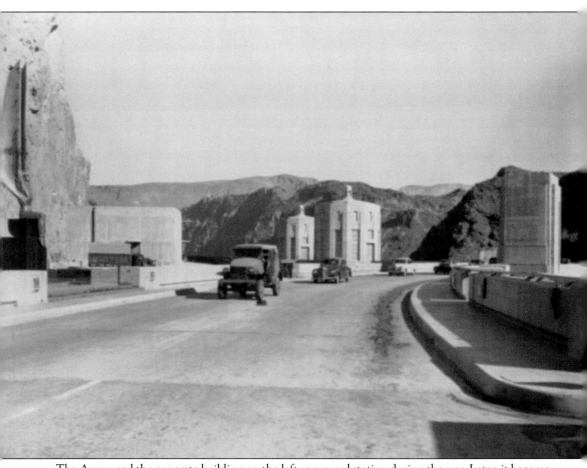

The Army used the concrete building on the left as a guard station during the war. Later, it became the Exhibit Building. The *Winged Figures of the Republic* appear as the silent guardians of Hoover Dam. Motorists had to remain in their vehicles while crossing the dam. (Courtesy of USBR.)

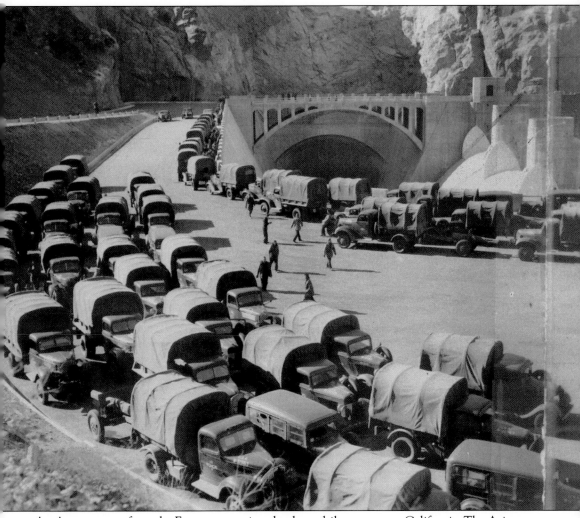

An Army convoy from the East stops to view the dam while en route to California. The Arizona Spillway is in the background. (Courtesy of USBR.)

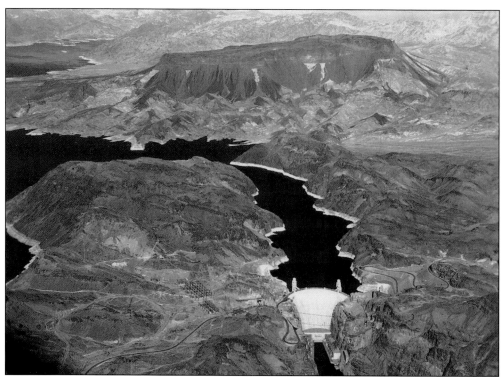

This aerial photograph shows Hoover Dam and a full Lake Mead. The lake reached its peak elevation, 1,025 feet, in the summer of 1938. (Courtesy of USBR.)

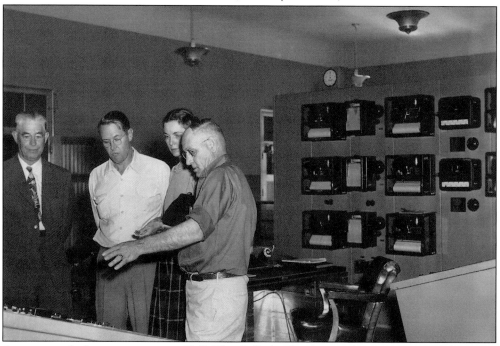

A new record of visitors was set in 1947. The Colladay family, seen here on a tour of the power plant, were the 376,405th visitors, breaking the record. (Courtesy of USBR.)

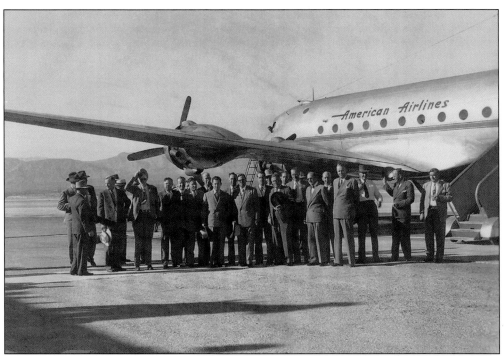

Tourists, movie stars, foreign dignitaries, and elected officials came to experience the nation's new marvel. In this image, the US House of Representatives Committee on Public Land Use arrives at McCarran Field on September 30, 1947, to inspect the dam and power plant. (Courtesy of USBR.)

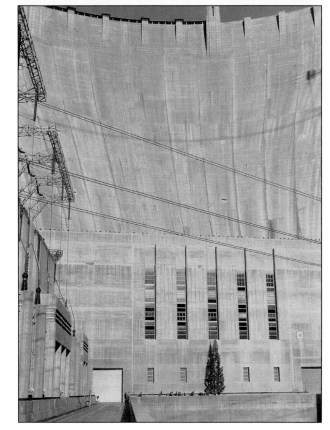

The postwar years were a time to give thanks. Here, Los Angeles Bureau of Power and Light employees decorate a 37-foot-tall Christmas tree on the Nevada-Arizona state line in December 1947. (Courtesy of USBR.)

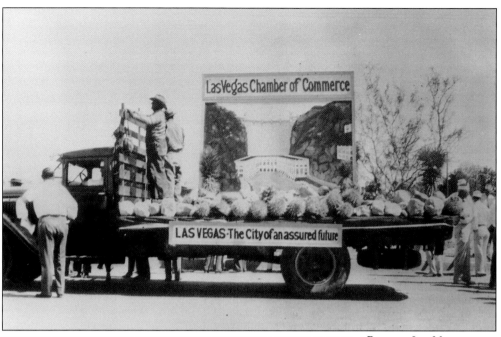

Because Las Vegas was only 30 miles from the dam, the chamber of commerce recognized the benefits of federal monies and tourism. This photograph was taken prior to the official name change in 1947. (Courtesy of UNLV.)

Southern Nevada has long catered to meetings and national conventions. These attractive young women helped market the Clark County Gem Collectors Convention at Lake Mead in October 1950. (Courtesy of LMNRA.)

USBR commissioner Lloyd Hudow takes the emir of Kuwait, Prince Rehad (center), and his entourage on a tour of the interior of the dam on October 20, 1950. (Courtesy of USBR.)

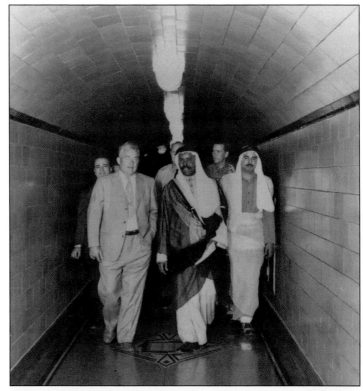

The 1952 National Park Service Lake Mead map shows parks and tourist destinations in the vicinity of Hoover Dam. (Courtesy of LMNRA.)

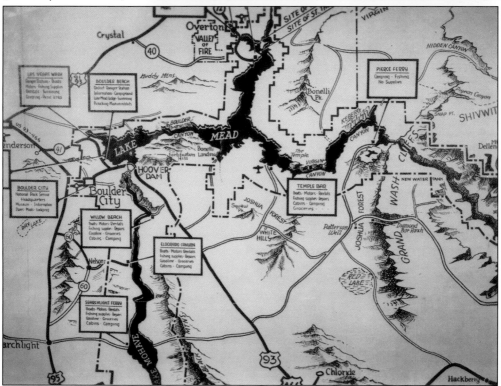

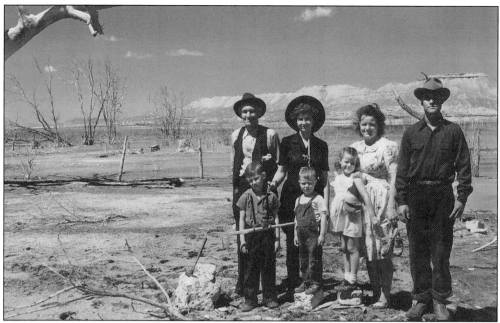

St. Thomas has reemerged from Lake Mead several times since it was inundated in 1938. Here, members of the John Perkins and Johnson families have returned to the site of their former home during a St. Thomas reunion in 1952. (Courtesy of USBR.)

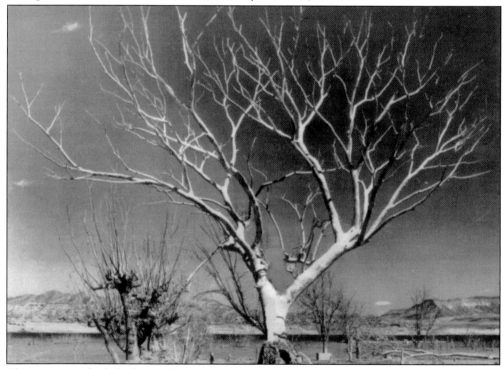

This tree once shaded John Perkins's front yard in St. Thomas (see page 27, top) and resurfaced during the drought of 1952. Dead trees were later cut down for the safety of boaters. (Courtesy of USBR.)

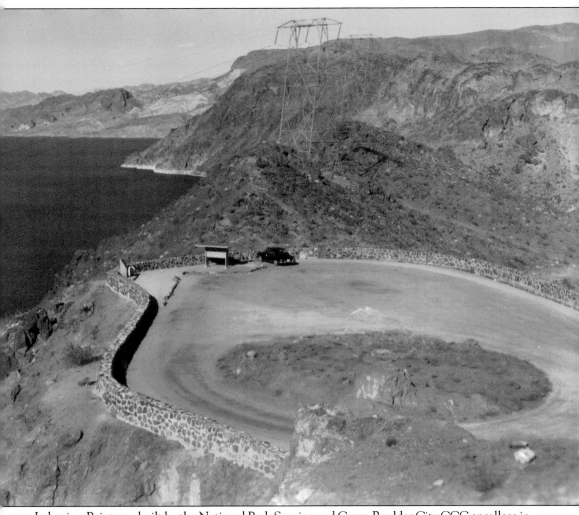

Lakeview Point was built by the National Park Service and Camp Boulder City CCC enrollees in 1937. This motorist has stopped to admire Lake Mead on the way to the dam in 1952. Today, the overlook is frequented by hundreds of automobiles and dozens of tour buses each day. (Courtesy of LMNRA.)

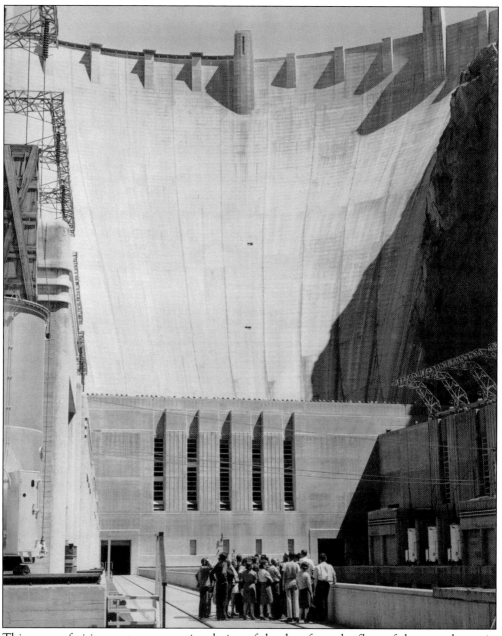

This group of visitors gets an exceptional view of the dam from the floor of the powerhouse in 1950. A record 448,081 people visited the dam and power plant in 1953. (Courtesy of UNLV.)

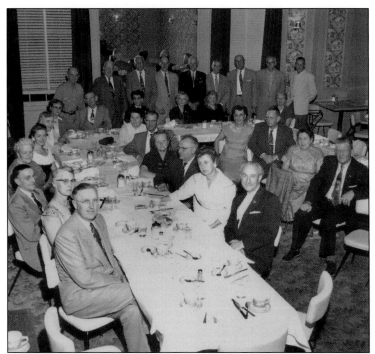

Hoover Dam pioneers reunited at a "31ers" luncheon at the Boulder Hotel in 1956. Originally, membership was restricted to Six Companies employees, contractors, or businesses in operation before January 1, 1932. Today, anyone who has resided in Boulder City for 31 years or is a descendant of a dam worker or a resident during dam construction is eligible to be called a "31er." (Courtesy of BCMHA.)

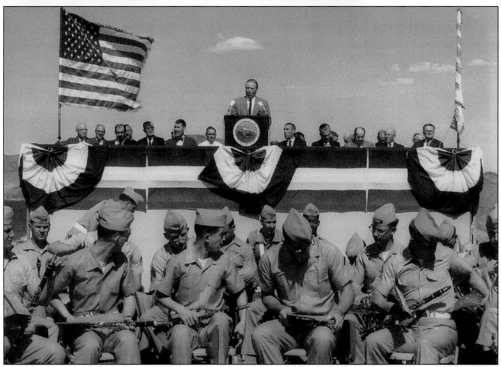

Floyd Dominy, one of the USBR's most colorful commissioners, is the master of ceremonies at the Senator Wash Dam dedication in 1966. Senator Wash Dam, two miles above Imperial Dam, was built to regulate the flow of water between Davis Dam and the Mexican border. (Courtesy of IID.)

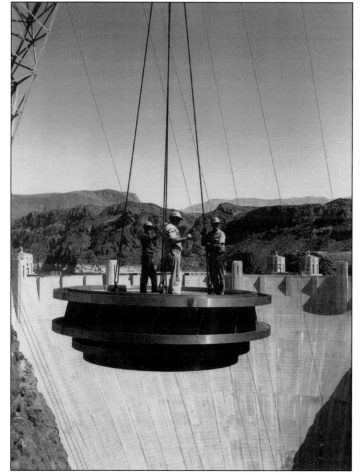

The Central Arizona Project ended decades of water disputes between Arizona and California. Shown here is the start of the Central Arizona Project. The aqueduct carries Colorado River water from the southern end of Lake Havasu to the Phoenix and Tucson areas. (Courtesy of LOC.)

The original cast-steel turbine runners installed in generators N1 through N4 were replaced with stainless-steel turbine runners beginning in 1968. The Allis-Chalmers Manufacturing Company delivered the 62,000-pound units and lowered them to the powerhouse using a 150-ton-capacity cableway. All of the original turbines were replaced by 1993. (Courtesy of USBR.)

Seven

THE CHALLENGES AHEAD

Hoover Dam has always faced challenges, from the passing of the Boulder Canyon Act and ratifying of the Colorado River Compact to the building of a mega-structure in the midst of the Great Depression. Its symbolism and importance to America made it vulnerable to enemy attack during World War II and the Cold War—as well as after the terrorist attacks of September 11, 2001. But the glory days of the big dams had lost some of their luster by the late 1960s. Environmentalists questioned its effect on wildlife and the landscape. Today, the federal government is confronted with new issues related to climate change, water shortage, and the spread of invasive species.

Of concern to all is the current drought and its implications to the future of hydroelectric power at the dam. The eight years ending in 2007 were the driest in the Colorado River's historical record. The lake's falling water levels may halt the production of hydroelectric power by 2017 if present trends continue. The demand for agricultural and municipal water now exceeds the supply. An underlying problem is the over-apportionment of the river based on 18 million acre-feet (maf). In reality, the annual flow has averaged between 15 and 16 maf. Water conservation alone cannot solve the dilemma.

Recently, Hoover Dam and Lake Mead were confronted by a downside of tourism: the introduction of invasive quagga mussels presumably from the Great Lakes. Currently, 1.5 trillion adult quagga mussels live in Lake Mead. Millions of dollars have been spent cleaning the mussels off of machinery and equipment and looking for ways to stop the spread into other waterbodies. Marinas have adopted procedures for washing watercraft before they enter the water, and the government has embarked on a national public awareness campaign.

In the aftermath of the recession, visitors are returning to Las Vegas. Boulder City, with its non-gaming ordinance, looks to green energy to ensure its future. Visitors are always welcome but large housing developments are not. While the entrance to town was recently updated, the downtown looks much as it did in the Hoover Dam construction days. Boulder City's 15,000 residents enjoy a quiet existence in the town that built Hoover Dam.

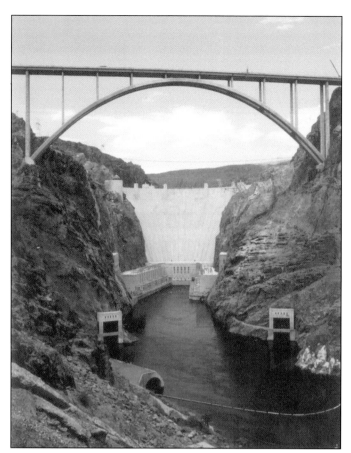

The Mike O'Callaghan–Pat Tillman Bridge in Black Canyon was completed in 2010 at a cost of $114 million. The bridge hovers over Hoover Dam a mere 1,500 feet to the north and provides an excellent view of the dam from the bridge walkway. There is no longer through-traffic on the dam, and visitors must turn back to get on US Highway 93 and enter Arizona. (Both, courtesy of USBR.)

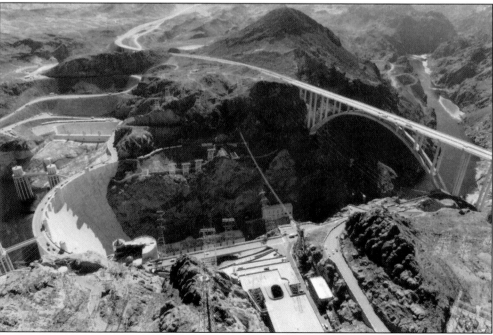

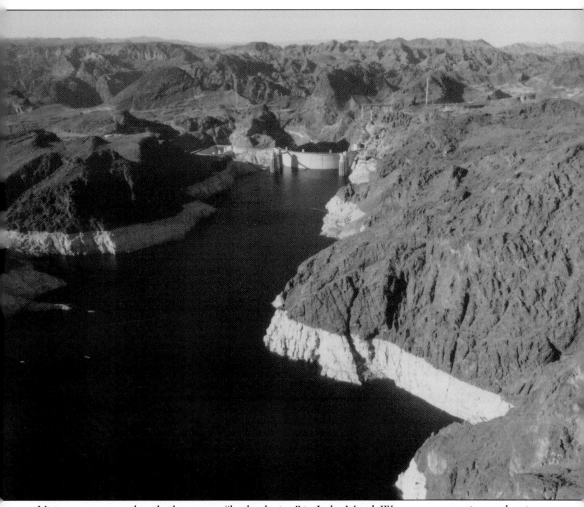

Visitors are amazed at the low-water "bathtub ring" in Lake Mead. Water experts estimate that it will take seven years of normal snowfall in the western Rocky Mountains to refill the reservoir. (Courtesy of USBR.)

In 2004, a pre-sedimentation tank used for screening and washing gravel during the Hoover Dam construction days emerged from the lake. Today, air passengers can see it protruding from Lake Mead along the flight path to McCarran International Airport. (Courtesy of USBR.)

Desert bighorn sheep herds had dangerously low populations in the 1930s but have multiplied in recent years. The River Mountains, west of Lake Mead, have the largest sheep populations in Nevada. The sheep are often spotted when they come down from the hills for water. (Courtesy of LMNRA.)

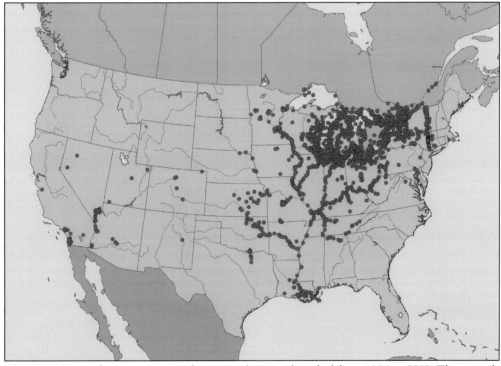

This map shows where quagga, or zebra, mussels were identified from 1986 to 2012. The mussels travel on the hulls of watercraft. To slow the spread, a growing number of marinas are requiring that boats be inspected and power-washed before they enter water bodies. Lake Mead and the lower Colorado River have the largest populations in the West. (Courtesy of USGS.)

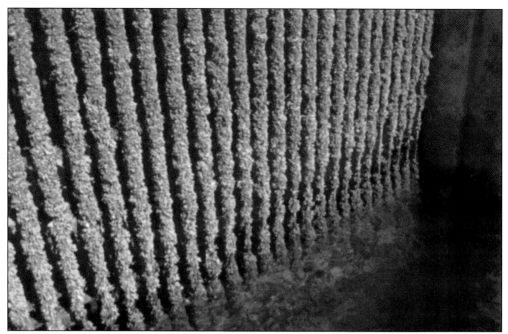

The intake towers protrude from the low reservoir in these 2011 photographs. Ongoing drought and low water in Lake Mead have reduced the power generation at Hoover Dam. Intrusive quagga mussels have coated tower "trash racks," requiring continuous and expensive maintenance. Federal and state agencies are looking for ways to deter future quagga colonization. (Both, courtesy of LMNRA.)

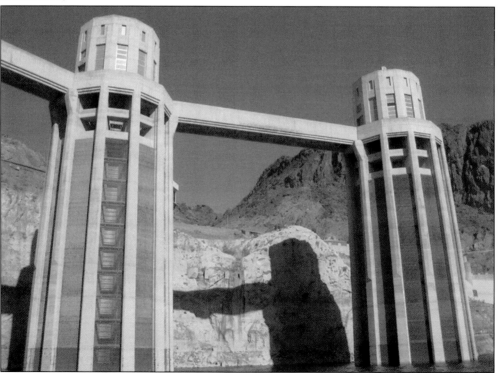

BIBLIOGRAPHY

Billington, David P. and Donald C. Jackson. *Big Dams of the New Deal Era: A Confluence of Engineering and Politics.* Norman: University of Oklahoma Press, 2006.

Billington, David P., Donald C. Jackson, and Martin V. Melosi. *The History of Large Federal Dams: Planning, Design and Construction.* Denver: United States Department of the Interior, Bureau of Reclamation, 2005.

Dunar, Andrew J. and Dennis McBride. *Building Hoover Dam: An Oral History of the Great Depression.* Reno: University of Nevada Press, 1993.

Ferrence, Cheryl. *Around Boulder City.* Charleston, SC: Arcadia Publishing, 2008.

Hiltzik, Michael. *Colossus: The Turbulent, Thrilling Saga of the Building of Hoover Dam.* New York: Free Press, 2010.

Hoover Dam. Denver: United States Department of the Interior, Bureau of Reclamation, 2006.

Hopkins, A.D. and K.J. Evans, eds. *The First 100: Portraits of the Men and Women Who Shaped Las Vegas.* Las Vegas: Huntington Press, 2000.

Lake Mead: The Story of Boulder Dam. Denver: United States Department of the Interior, Bureau of Reclamation, 2008.

Nadeau, Remi A. *The Water Seekers.* Bishop, CA: Chalfant Press, 1974.

Pfaff, Christine. "Safeguarding Hoover Dam during World War II." *Prologue* 35, no. 2 (2003).

Reisner, Marc. *Cadillac Desert: The American West and its Disappearing Water.* New York: Penguin Books, 1986.

Rodden, Mimi Garat. *Boulder City, Nevada.* Charleston, SC: Arcadia Publishing, 2000.

Rogers, J. David. "Hoover Dam: Scientific Studies, Name Controversy, Tourist Attraction, and Contributions to Engineering." Hoover Dam 75th Anniversary History Symposium, Las Vegas, October 2010.

Simonds, William Joe. *Hoover Dam: The Boulder Canyon Project.* Denver: United States Department of the Interior, Bureau of Reclamation, 2009.

Stevens, Joseph E. *Hoover Dam: An American Adventure.* Norman: University of Oklahoma Press, 1988.

DISCOVER THOUSANDS OF LOCAL HISTORY BOOKS
FEATURING MILLIONS OF VINTAGE IMAGES

Arcadia Publishing, the leading local history publisher in the United States, is committed to making history accessible and meaningful through publishing books that celebrate and preserve the heritage of America's people and places.

Find more books like this at
www.arcadiapublishing.com

Search for your hometown history, your old stomping grounds, and even your favorite sports team.